INDUSTRY and INTELLIGENCE

Bampton Lectures in America
‖‖‖

Bampton Lectures in America

The Prospects of Western Civilization, Arnold J. Toynbee, 1940

New Discoveries in Medicine: Their Effect on the Public Health, Paul R. Hawley, 1950

Gospel and Law: The Relation of Faith and Ethics in Early Christianity,
 Charles H. Dodd, 1951

Art and Technics, Lewis Mumford, 1952; reprinted with a new introduction by
 Casey Nelson Blake, 2000

Modern Science and Modern Man, James B. Conant, 1952

Challenges to Contemporary Medicine, Alan Gregg, 1956

The Idea of Revelation in Recent Thought, John Baillie, 1956

Four Steps Toward Modern Art: Giorgione, Caravaggio, Manet, Cezanne,
 Lionello Venturi, 1956

Science in the Making, Joel Henry Hildebrand, 1957

Prescription for Survival, Brock Chisholm, 1957

The Importance of Being Human: Some Aspects of the Christian Doctrine of Man,
 Eric Lionel Mascall, 1958

The Art of William Blake, Sir Anthony Frederick Blunt, 1959

From Miasmas to Molecules, William Barry Wood, 1961

Christianity and the Encounter of the World Religions, Paul Tillich, 1963

A Natural Perspective: The Development of Shakespearean Comedy and Romance,
 Northrop Frye, 1965

Man in the Universe, Fred Hoyle, 1966

Mental Illness: Progress and Prospects, Robert H. Felix, 1967

The Religious Significance of Atheism, Alasdair MacIntyre and Paul Ricoeur, 1969

Victorian Architecture: Four Studies in Evaluation, Sir John Summerson, 1970

Magic, Science, and Civilization, Jacob Bronowski, 1975

Titian: His World and His Legacy, David Rosand, ed., 1982

Faith and Reason, Anthony Kenny, 1983

Language and Information, Zellig Harris, 1988

The Painter's Practice: How Artists Lived and Worked in Traditional China,
 James Cahill, 1994

The Crusades, Christianity, and Islam, Jonathan Riley-Smith, 2008

Liam Gillick

INDUSTRY and INTELLIGENCE

Contemporary Art Since 1820

Columbia University Press ✺ *New York*

Columbia University Press
Publishers Since 1893
New York Chichester, West Sussex
cup.columbia.edu
Copyright © 2016 Columbia University Press
All rights reserved

Library of Congress Cataloging-in-Publication Data
Gillick, Liam, 1964– author.
 [Works. Selections]
 Industry and intelligence : contemporary art since 1820 / Liam Gillick.
 pages cm. — (Bampton lectures in America)
 Includes bibliographical references and index.
 ISBN 978-0-231-17020-8 (cloth : alk. paper) — ISBN 978-0-231-54096-4
 (e-book)
 1. Art, Modern—Themes, motives. 2. Art and society. I. Title.
 N6490.G485 2016
 709.04—dc23

 2015020970

Columbia University Press books are printed on permanent and durable
acid-free paper.
This book is printed on paper with recycled content.
Printed in the United States of America

c 10 9 8 7 6 5 4 3 2

Cover and book design: Lisa Hamm
Cover image: *Hamilton* (A Film by Liam Gillick), 2014
Film 27:43 min duration, Mirrored Room
Courtesy of the artist, Esther Schipper, Berlin
& Maureen Paley, London
Private collection

References to websites (URLs) were accurate at the time of writing.
Neither the author nor Columbia University Press is responsible for URLs
that may have expired or changed since the manuscript was prepared.

Contents

Acknowledgments *vii*

Introduction: Creative Disruption in
the Age of Soft Revolutions *ix*

1 Contemporary Art Does Not Account for
That Which Is Taking Place 1

2 Projection and Parallelism 13

3 Art as a Pile: Split and Fragmented Simultaneously 17

4 1820: Erasmus and Upheaval 21

5 ASAP Futures, Not Infinite Future 35

6 1948: B. F. Skinner and Counter-Revolution 37

7 Abstract 51

8 1963: Herman Kahn and Projection 57

Contents

9 The Complete Curator 71

10 Maybe It Would Be Better If We Worked
 in Groups of Three? 79

11 The Return of the Border 87

12 1974: Volvo and the Mise-en-Scène 91

13 The Experimental Factory 105

14 Nostalgia for the Group 111

15 Why Work? 117

 Notes 129

 Index 133

 Photo section follows page 56

Acknowledgments

I would like to thank Professor Mark C. Taylor of Columbia University's Department of Religion and Professor Gregory Amenoff of Columbia University's School of the Arts, who invited me to present the Bampton Lectures and were enthusiastic and encouraging at every moment. I would also like to thank Alfonso Artiaco, Florence Bonnefous, Darragh Hogan, Renate Kainer, Casey Kaplan, Edouard Merino, Christian Meyer, Taro Nasu, Maureen Paley, Eva Presenhuber, Esther Schipper, and Micheline Szwajcer for their support over the years. Piper Marshall witnessed the development of the lectures and was an incisive critic. Finally, to the students of Columbia University Visual Arts Program between 1997 and 2013, I was and remain deeply impressed.

Parts of this book appeared in the online journal *e-flux*. I would like to thank Julieta Aranda, Anton Vidokle, and Brian Kuan Wood for their support and dynamic exchange of ideas over the last few years. Other parts appeared in two books of collected essays edited by Paul O'Neill and Mick Wilson. I would particularly like to thank Paul O'Neill for his engagement and critique.

Chapter 1 appeared in a different form as "Contemporary Art Does Not Account for That Which Is Taking Place," *e-flux* 21 (2010).

Chapter 5 appeared in a different form as "ASAP Futures, Not Infinite Future," in *Curating and the Educational Turn*, ed. Paul O'Neill and Mick Wilson (London/Amsterdam: Open Editions/De Appel, 2010).

Chapter 7 appeared in a different form as "Abstract," in *Micro-Historias y Macro Mundos*, vol. 3, ed. Maria Lind (Mexico DF: Instituto Nacional de Bellas Artes y Literatura, 2010).

Chapter 9 appeared in a different form as "The Complete Curator," in *Curating Research*, ed. Paul O'Neill and Mick Wilson (London/Amsterdam: Open Editions/De Appel, 2014).

Chapters 13 and 14 appeared in different forms as "Maybe It Would Be Better If We Worked in Groups of Three? Part 1 of 2: The Discursive," *e-flux* 1 (2009); and "Maybe It Would Be Better If We Worked in Groups of Three? Part 2 of 2: The Experimental Factory," *e-flux* 2 (2009).

Chapter 15 appeared in a different form as "The Good of Work," *e-flux* 16 (2010).

Introduction

Creative Disruption in the Age of Soft Revolutions

The first of three film versions of the book *Of Human Bondage* was produced in 1934.[1] At the opening, we join the doomed hero of the movie, Philip Carey—played by Leslie Howard—as he seeks the opinion of his French art teacher on the merits of his paintings after some years of study in Paris. A short exchange ends with a simple condemnation. Carey's work shows industry and intelligence, nothing more. And therefore he should abandon all hopes of becoming an artist and choose another direction in life. Cutting to London, the narrative develops into a story of loss and lack—of tragically unrequited passion redirected onto the ungrateful character of waitress Mildred Rogers—a role played by Bette Davis with withering indifference. In common with most romantic yet inverted portrayals of art and artists in cinema, the teacher's condemnation asserts a lack in Carey's art that cannot be described—a certain something—a certain quality. In lieu of the realization of something *indescribable and unobtainable*, the two protagonists embark on a life of mutually ensured suffering and ultimate destruction.

Eighty years later, art in its current forms is the product of a complex of events, constructed personas, and critical tendencies. It is fragmentary and increasingly subjective. Contemporary art is a repository for various recognitions and desires; at the same time, it may be defined by its self-conscious stand for and against other art. Contemporary art is a record of material facts derived from art intentions, and it often remains just out of reach of the artist and viewers while at the same time remaining lucid, simple, and easy to read. This is the heart of contemporary art's challenge: a louche combination of clarity, resistance, reference, and subjectivity. And at the heart of contemporary art is the very combination of industry and intelligence that the hammily played art teacher in *Of Human Bondage* complains about. Neither industry nor intelligence implies or suggests anything about *quality* or *aesthetics*; these are philosophical concerns. Industry and intelligence can result in a conscious or unaffected clumsiness yet result in an intellectually complex web of references. From Andy Warhol to Andrea Fraser to Hito Steyerl, from Jackson Pollock to Felix Gonzalez-Torres to R. H. Quaytman, the one thread connecting these artists is their industry and intelligence in the face of what eludes representation and remains just out of reach. Industry and intelligence are not synonyms for hard work and skill—they are conditions of production under which contemporary art emerges, thrives, and resists.

Contemporary art endures. It survives because it is neither the product of a true academy nor an artist-critic-generated description of choice but rather a term that has for some time been a tolerable description for an increasingly wide range of art and artlike activity that cannot be completely captured by modernist or postmodernist accounts of visual art. Contemporary art is a leaky container that can accommodate many contradictory structures and desires.

This book is centered on a series of lectures delivered at Columbia University in 2013.[2] The edited lecture material is punctuated by some of my other writing from around the same time in order to address issues that could not be accommodated in the series and to focus on certain supporting ideas in more depth than was possible in a lecture form. The lectures focused on four dates: 1820 and three more between the end of the Second World War and the fall of the Berlin Wall—1948, 1963, and 1974. The dates were not chosen because they are central—the paradox of contemporary art means that there are no special years; all years are special when considering the multiple strands of its accommodating structure. In the classic manner of the contemporary artist, I chose these years for a subjective reason. They are used to indicate how a specific subjective history of events, technologies, and desires contributes toward the fabrication of the contemporary artist as a constructed persona. Other dates could have been chosen, but these are specific as moments I have focused on in four main bodies of work since the early 1990s.[3] These are the dates I know the most about, and they have functioned for me as research dumps of knowledge.

But this does not mean that these dates are random. In the work I have done over the last twenty-five years, there are reasons why I circled around these dates. They reveal hidden turning points and cached moments of shift and transition. These are dates where we find compromise, negotiation, revision, projection, and delay—shifts of exchange technologies and new approaches to behavior and desire. The original title of the lectures was *Creative Disruption in the Age of Soft Revolutions*. This book examines soft revolutions in science, politics, and technology and suggests that the figure of the contemporary artists we encounter today is a result of their industry and intelligence in the face of shifts and transitions. This interplay between soft revolutions and industry and intelligence developed

long before art fairs or symposia on the curatorial turn. The persona of the contemporary artist was made possible at the moment a new amateur emerged in response to the Enlightenment during the gap between the American and French republican revolutions and the European federalist upheavals of 1848. It was at this point that new figures and technologies merged to produce speculative visions combined with a new conception of *time made available* to pursue individual lines of research in parallel to the academy and patronage. In short, 1820 is my suggestion for a starting point where *interests* can be developed, tolerated, and encouraged in a semiautonomous way. *Contemporary Art Since 1820* does not mean that this book is an account of art made since that time. But the story must begin at that point in order to convey the origins of the industry and intelligence that produce the conditions for the production of contemporary art. As we will see, this ultimately leads us to the problematic appropriation of *creativity* and individual motivation as the cognitive capital that is at the heart of neoliberal capital's hold on developed modes of organization today, a hold that produces stress and anxiety about contemporary art's complicity, success, and limits as it attempts to operate as neoliberalism's critical double.

Art since the challenge to the academies has taken its most dynamic forms in opposition to, in advance of, and in response to moments of rupture and change rather than operating at the heart of the catastrophic or heady moments of the last 150 years. It is the soft revolutions in parallel to the main events where we can find a trace of contemporary art's genealogy and focus—moments identified by artists and played with in deliberate opposition to dominant narratives and in league with the production of new subjectivities.

Contemporary art resists and embraces its own interrogation—that's what makes it contemporary art. Anything posed toward it is absorbed by contemporary art's contingencies. Rather than assert a route through this

in an attempt to produce an inventory of good works or special cases, it might instead be more useful to find out how contemporary art has developed its current forms and denials. I am reduced to this task via the use of genealogy rather than archeology—genealogy here following the line of Foucault: "The constitution of the subject across history which has led us to the modern conception of the self." Further,

> three domains of genealogy are possible. First, a historical ontology of ourselves in relation to truth through which we constitute ourselves as subjects of knowledge; second, a historical ontology of ourselves in relation to a field of power through which we constitute ourselves as subjects acting on others; third, a historical ontology in relation to ethics through which we constitute ourselves as moral agents.[4]

The original lectures that constitute the heart of this book lay out a history of soft revolutions that have contributed to the conditions for contemporary art's development, existence, and survival. This is not an account of shattering moments of political upheaval or aesthetic breakthrough—it is an artist's attempt to look at specific moments. For it is clear that a reading of the genealogy of contemporary art filtered through catastrophic revolution, collapse, and breakthrough cannot effectively account for what is taking place now—such moments have excessive significance. I would argue that we only find traces of them amplified, diminished, and infinitely reflected in the theoretical frameworks that both underscore and overwrite art today. Art today meanders in direct contradiction or apparently blind to the very significance of the key events that take place around it. As such it is *critical* even when it is apparently *disengaged*.

Each lecture had three parts. The first of each outlined the temporal stresses that led to new conceptions of agency or repression within

contemporary art. The second part outlined the bounding ideas that were either the result of or an exception to these temporal stresses. The final part of each lecture attempted to explain the application effect of these temporal stresses and bounding ideas in a framework of contemporary art. So while the lectures appeared to circle around four specific dates, they really pointed forward from these dates toward a notional present—flying over one another as a series of parallel narratives, all of which might be required to construct a particular understanding of how we got to this point and therefore maybe indicate a border zone—or at least what might happen next. The structure of each lecture allowed me to explain how certain situations and effects have been carried through time as embedded memories—whether governmental (educational, bureaucratic, infrastructural), social (power relations, sense of inclusion/exclusion/agency), or technological (tools, trajectories, control devices, and limits/extensions to expression).

The first lecture sprung forward from 1820 and addressed the emergence of autonomy as a desire and the problems of its realization. The second lecture, starting in 1948, looked at the emergence of new structures in the wake of war, upheaval, and breakdown in the reconstitution of empires. The third lecture made use of 1963 as the moment when we sensed the arrival of the conscious agent—both cached and in the open. And the final lecture—pivoting around 1974—addressed the collective and the problem of increasing ennui on the verge of new technologies and infinite redundancy.

And in contradiction of my earlier putting aside of philosophy, I will allow myself a couple of short quotations that might at least signal my approach. I trust they are useful:

There are works which common opinion designates as works of art and they are what one must interrogate in order to decipher in them the essence of art. But by what does one recognize, commonly, that these are

works of art if one does not have in advance a sort of pre-comprehension of the essence of art? This hermeneutic circle has only the (logical, formal, derived) appearance of a vicious circle. It is not a question of escaping from it but on the contrary of engaging in it and going all round it: "We must therefore complete the circle."[5]

Genealogy retrieves an indispensable restraint: it must record the singularity of events outside of any monotonous finality; it must seek them in the most unpromising places, in what we tend to feel is without history—in sentiments, love, conscience, instincts. . . . Genealogy must define even those instances when they are absent, the moment they remained unrealized. . . . It [genealogy] opposes itself to the search for "origins."[6]

In the gap between Derrida and Foucault we can find tools to recognize and decode the contemporary artwork and the techniques that govern its presence and power. Most other recent attempts to examine the status of the artwork end with platitudes or truisms, ontological games, or existential forms of nominalism. Art resides in power relations, speech acts, points of view, and extremely complicated semiotic games. Everything else is luster, hubris, or expressions of pious good taste.

INDUSTRY and INTELLIGENCE

ONE

Contemporary Art Does Not Account for That Which Is Taking Place

The term *contemporary art* has historically implied a specific accommodation with a loose set of open-minded economic and political values that are mutable, global, and general and therefore have sufficed as an all-encompassing description of *what is being made now—wherever.* But the flexibility of contemporary art as a term is no longer sufficiently capable of encompassing all dynamic current art, if only because an increasing number of artists seek a radical differentiation. Recently in the essay "Why Work" I attempted therefore to re-term contemporary art in a more precise sense, rephrasing it as *current art*, as a way to drop the association with the contemporary of design and architecture and find a term that would be a way to talk about the near future and recent past of engaged art production rather than an evocative postmodernistic inclusively of singular subjective practices.[1] However, this new adjusted definition does not suffice as a description that can effectively include all the work that is being made with the intention of resisting the flexibility of contemporary art. Recent focus upon the documentary, educational models and engaged social collaborations have attempted to establish and describe new relationships

that operate outside and in opposition to the apparently loose boundaries of the contemporary. These are engaged structures that propose limits and boundaries and take over new territories, from the curatorial to the neoinstitutional, in direct opposition to the loose assumptions of the contemporary, in both its instrumentalized and capitalized forms. It is increasingly difficult to ignore the fact that contemporary art has been taken up as a definition in such apparently mutually exclusive arenas as auction houses and new art history departments as a way to talk about a generalization that always finds articulation as a specificity or set of subjectivities that may no longer include those who work hard to evade its reach.

Contemporary art is inextricably linked to the growth of doubt consolidation. The term "contemporary art" is marked by its excessive usefulness. The contemporary has exceeded the specific of the present. It has at the same time absorbed particular and resistant groupings of interests, all of which have become the multiple specificities of the contemporary. The people who leave graduate studio programs are contemporary artists—that much is clear. They represent the subjective artist operating within a terrain of the general. Yet we now find that the meaning of contemporary art is being redefined by a new art historical focus upon its products, ideas, and projections. That means we are going through a phase where—whether we like it or not—it is quite likely that new terminology and delineation will be proposed. Therefore it is necessary for artists specifically—although never alone—to engage with this process of redescribing what gets made now. What is the image of the contemporary? And what does the contemporary produce other than a complicit alongsideness?

The contemporary is necessarily inclusive—a generalization that has shifted toward becoming an accusation. Is there the possibility of merely saying *I make work now*? Contemporary art is a phrase that lends itself to

being written and told without being said. It is always *everyone else*. Stopping saying the term would only work if people had been saying it all along. It is as rare to hear an artist describe themselves as a contemporary artist as it is to hear an architect tell you they are a contemporary architect. This sense of the unsaid has emphasized the role of the contemporary as a loose bounding term that is always pointing away from itself rather than being articulated and rethought from the center. That is the reason for its durability and stifling redundancy.

The installation—and by association the exhibition itself—is the articulation of the contemporary. Even paintings cannot escape this *installed* quality, the considered and particular installation of things and images, even when approached in a louche or offhand manner. We all have an idea of what contemporary art represents while only knowing the specifics of any particular instance. It is this knowing what it means via evoking a particular instance that pushes people toward an attempt to transcend this generality. Contemporary art has at the same time become historical, a subject for academic work. The autumn 2009 issue of *October* magazine on the question of the contemporary tended to focus on the academicization of contemporary art while acknowledging extensively the existing unease that many artists have with being characterized within a stylistic epoch—Hal Foster noted that the magazine received very few replies to his questionnaire from curators.[2] This may be because the *October* issue coincided with the end of the usefulness of the term "contemporary art" for most progressive artists and curators—or at least with the reluctance of more and more to identify with it—while remaining a convenient generalizing term for many institutions and exchange structures including auction houses, galleries, and art history departments, all of whom are struggling to identify the implications of their use of the term—some more than others, of course.

Donald Judd did not identify himself as a minimalist.[3] Artists tend to deny that they are part of something that is recognized and defined by others. Frustrations are always unique. Contemporary art activates denial in a specifically new way. It does not describe a practice but a general *being in the context.* One recent solution to the way the contemporary subdues via an excess of differentiation has been to separate the notion of artistic and other political engagement, so that there can be no misunderstanding that only the work itself, in all its manifestations, might be part of the *contemporary art context.* A good example here would be Paul Chan, who has been described in biographies as an "artist and activist"[4] in order to differentiate his engaged social function as a political agent from his work within galleries and museums. We are aware that the activism feeds the art and that the art feeds the activism, but in a distinct step away from the artist's role in the shadow of conceptual art we find it is now necessary for many such as Chan to show that there is a limit or border to the embrace and effectiveness of contemporary art. Of course, there is a potential problem here in terms of how we might define activism, for example, along with the use of the documentary among progressive artists. Taking a term such as "activism" and combining it with an artistic practice that is clearly *of the contemporary* shows a tendency to associate with earlier forms of certainty. It is one form of a reluctant acceptance that it is currently impossible to escape the hold of the contemporary but that it might be possible to separate life and action from contemporary art. In these cases, we continue to read the work through the hold of the contemporary in terms of what gets made, but we do this via an understanding that there are these other daily social activities that are not part of the *contemporary art context*—they do not share its desires, projections, and results.

So what is the contemporary of contemporary art? Does art itself point to the term, or vice versa? What's going on? Have people forgotten to ask

artists if they are contemporary artists? One answer is that it is a convenient generalization that does not lend itself to reflection and constant rethinking in the manner of established theoretical structures such as postmodernism. It allows a separation from the act of making or doing art and the way it is then presented, explained, and exchanged. Both artists and curators can find a space in a gap between these two moments where they are temporarily considering an exceptional case with every new development or addition to the contemporary inventory. Yet an inventory of art spaces alone, for example, cannot help us find a categorization of participation within the realm of the contemporary. The question is how to categorize art today in a way that will exceed the contemporary. The inclusiveness of the contemporary is under attack, as this very inclusiveness has helped suppress a critique of what art is and, more importantly, what comes next. We know what comes next as things stand—*more contemporary art*.

There has been a proliferation of discussions and parallel practices that appear to operate in a semiautonomous way alongside contemporary art. They ignore it or take the work of the contemporary as an example of what not to do. A good example might be the *Unitednationsplaza* and *Nightschool* projects in Berlin, Mexico DF, and New York,[5] a series of discussions and lectures framed within the idea of an educational setting. While the discussions and lectures appeared to address the possibilities of art now, there seemed to be very little anxiety about the idea of actually bypassing the production of recognizable contemporary art forms. The project itself was a melding of the curatorial, the artistic, and academic toward the creation of a series of discursive scenarios that might defy not the commodification of art but the absorption of everything within the tolerant regime of contemporary production. The mediation of one's own practice creates moments of escape from the contemporary. Still, seeing this production of parallel knowledge creates a dilemma when it becomes the primary production of

So, new consciousnesses around education and documentation provide glimmers of clarity within the inclusive terrain. Inclusion and exclusion suddenly become moments of clear choice—political consciousness starts to affect the notion of specific practice, for example, thinking about the problem of contemporary art while producing new networks of activity that are marked by their resistance to contemporary art as a generality. It is the lack of differentiation within the contemporary that leaves it as an open speculative terrain. This is what drives the discursive and the documentary as somewhat passive yet clearly urgent oppositions.

So what is contemporary of contemporary art? The contemporary is more successful within cities. It relates to the increasing deployment of contemporariness as a speculative terrain of lifestyle markers that include art. The contemporary implies a sophisticated sense of networking. Making things with an awareness of all other things. Joining a matrix of partial signifiers *that will do*. Relativism in this case is merely defined by context and is a nonactivated neopolitical consciousness. Within the contemporary there is a usefulness about all other work. And there exists a paradox of an antirelativism within the subjectivity of each artist and every art work. Yet an increasingly radical antirelativism, shared by many, causes unacknowledged tensions. The contemporary is marked by a displayed self-knowledge, a degree of social awareness, some tolerance, and a little bit of irony, all combined with an acknowledgment of the failure of modernism and postmodernism or at least a respect for trying to come to terms with the memory of something like that failure. The contemporary necessarily restricts the sense in which you are looking for a breakthrough. An attempt to work *is* the work itself. Unresolved *is* the better way, leaving a series of props that appear to work together—or will do for now. In this case no single work is everything you would want to do. This is the space

of its dynamic contradiction. Hierarchy is dysfunctional and evaded in the contemporary, and, therefore, key political questions, whether ignored or included, are supplemented by irony and coy relations to notions of quality.

There is, in the forefront, the question of how much to produce and when rather than what to produce—all while secretly producing what could easily have been made public. This has led to an endlessly produced white noise of seminewness linked to a withholding of work. Work as an affirmative neurotic leisure. It is necessary to differentiate ways of working. Not working at all is very hard to do. So the answer is to keep working within a limited form of conceptual difficulty. Using a philosophical base is generally assumed as the critical *Big Other*,[8] and thinking about other art is the way to define a degree of subjectivity within the matrix. Knowing which *personal* to occupy helps here. We must assume that everyone and everything is right and true. Trying on different personalities is forgiven within this realm. The decision to change is an obligation. Burning paintings is the originating myth. The point is to join the highway via the onramp at full speed. Then choose which lane to occupy. Slowing down or getting on or off again is difficult and undesirable. Difficulty is internal in this place. A completely different person emerges to occupy this internal space of thought and action. The contemporary is always an internal thing expressed only partially in the external. It is full of ways to be misled and involves the avoidance of totalizing shifts masked by stylistic changes. Defying history becomes a complete rupture. Defying history is part of the past. Contemporary art becomes more and more inclusive of its own past and eternal future.

The contemporary comes to terms with accommodation. Fundamental ideas are necessarily evaded, for the idiom of the contemporary still carries the lost late-modernist memory of a democratization of skill and active participation by the viewer. Its grounding principles are based on these

apparently universal potentials. By your nature you are a contemporary artist by taking the decision to announce yourself. It is easy to *be*—just existing through work. The process functions in reverse sometimes. A coming into being through work. A place in the contemporary frame is established by a pursuit of contemporary art, not the other way around. Collective and documentary forms have attempted escape and attempted to establish a hardcore, activist separation, a critique of anything and everything. There has developed a need to find a secondary ethics to establish a zone of difference: tweaking tiny details and working as another character alongside the contemporary. Historically speaking, all profound "-isms" in art were originated by artists—in the case of the contemporary you are the originator of all subjectivities. But how can we avoid the postcontemporary becoming a historic nostalgia for the group or mere political identification by self-exclusion? The basic assumption of the contemporary is that all we need is a place to show—to be part of and just toward the edge of contemporary art. Everyone in this zone of the exhibited becomes the exception within the tableau. This leads to project-based strategies that paper over the neurosis of the exposed. Desire and drive and motivation are sublimated. Every project-based approach creates a hypothetical method that endorses the mutable collective. Seeing is clearly combined with instinctive moments that are always building something in a self-conscious web, all contributing to a matrix of existing forms and justified by continued reappearance.

The work always projects into the future while holding the recent past close at hand. It predicts the implications of itself and builds a bridge between the almost known but half forgotten and the soon to be misunderstood. The contemporary artwork is always answering questions about itself and all other contemporary art. It used to be said that art is like theoretical physics—a specialization with a small audience. It could have been

a perfect research-based existence. Yet in a world where the contemporary artist is considered cynical, you never meet an artist who completely gives up. The perceived lack of audience is transformed into layers of resistance—not to the work itself but to the encompassing whole. The contemporary is therefore the place of dynamic contradiction where the individual work is never more than the total effect. No singular work has more value in terms of function than any other. The discourse of contemporary art revolves around itself. It has become impossible to be outside and therefore understood in separation. There is always an interest in showing something somewhere. Politics and biography have merged. We are all tolerant of art that is rooted in specific stories. This is the inclusive zone where the artist plays with their own perspective for a collective purpose. The drive is toward unhooking from who you are while simultaneously becoming only yourself. Some people can sleep with their eyes open. What does it do, this process of constantly discovering yourself? Pushing for recognition? The creation of *exceptional individuals of globalization*—an aristocracy of labor—in the words of Shuddhabrata Sengupta.[9]

Are we, within the slightly proven of the contemporary, left with rankings, museum shows, money, and newness as markers of something within its institutional forms? Working continues in a flow determined by economic conditions. And the obligation is to keep defending contemporary art in general, even if you find it impossible. It might be better to attempt a description of the free flow of ideas within inclusivity. Audiences create barriers and obstructions in a soft war of aesthetic tariffs that regulate flow and consensus. Tiny flows and minor disagreements fake drive and resist the external. The painful flow of life is sublimated. Change happens to other things but not within the realm of the contemporary. Boycotting everything is no longer an option; the strikes and protests will be included too. The system is resistant. Moving against a stream is a problem, for

the stream goes in every direction. Neurotic work is the reward. Something will come. Excessively working is the contemporary struggle. Where capital is globalized it is necessary to be everywhere. Gathering to create exchange with people amid the evidence of the contemporary—even when we are involved in a critical symposium. For despite the fact that each language has its own rules and gaps within in it, we find that it is impossible to find true contradiction within these boundaries. Where would we find this gap? A hardcore perspective is always tolerated. Who's being upset and irritated? Bourgeois value and capitalism is comfortable with every iteration of the contemporary; they literally support it. The contemporary offers a specific tangent with a narrative. No longer does anyone care who did what first; the idea of the original doesn't matter. This has been a style era rather than one of specific moments of change or development.[10] At the edge of practice we only find more things to be absorbed. At the center is a mass of tiny maneuvers. Self-consciousness constantly rebuilds this site of continuity. It is stacked with self-referential work, all ready for self-aware rereading, actions, and gestures. Certain terms have been established and a kind of lingua franca agreed to. It is a zone where it is possible to trust yourself within confusion. Learn communication skills. All the while, students get smarter and recognizably different, ironic in a way that levers the critical tone a little higher and eases the zone a little wider. Within this vague contemporariness people see more and more than they saw before. That is the genius of the regime. Contemporary art is the perfect zone of deferral. No clarity can be overcomplicated when it is reproducing itself endlessly. Here we can encounter slightly different situations every day. Feuds with good people will not create a rupture here any more than the condemnation of obscenity. The problematic cannot be destroyed. Jealousy in this environment is exhausting and unproductive. Instrumentalization at the institutional level is always in place in

societies over the last 150 years saw the victory of speculation over planning. Projection is the partner of speculation, whereas planning is the less agile sibling of projection. Projection is an essentially capitalist mode of analysis that is crucial to understanding the potential future profits and stresses of the contemporary corporation in context. Projection exists as a series of desires that all run in parallel—never coinciding—dividual and split. And parallelism is the structure of projection.

Artworks that generate descriptive potential within current advanced art cannot be reduced or consolidated. Descriptive potential means new forms or idea structures that can be used. While not necessarily didactic—descriptive structures tend toward producing a use value rather than recording a state or an abstraction alone. Such objects or structures with descriptive potential cannot be reduced or consolidated, for they include elements of self-awareness in their deployment that recognize limitations and contextual influence. These artworks are always incomplete but carry markers of their incompletion. There are always exceptions when trying to apply classically reductive narratives to such artworks. They cannot be simplified, as they are reified at their origin, their deployment, and their analysis; they are concrete and have a self-conscious thingness built in from the outset, a thingness not limited to form but that includes structure—both applied and anticipated. The decision to disperse something into the art context in this case does not produce a synthesis of ideas and forms but an endless series of strings that appear to cross and intersect. But such intersection is an illusion, the effect of the institutional, instrumental, and exchange component of the art context. When rotated and viewed from varied perspectives, the deployed ideas of art move through time as end-lessly parallel lines with no possibility of cohesion or consolidation.

Further—the intention to produce an artwork that might, in whatever form, somehow carry a direct connection between the self-perceived ethical

stance of the artist and the material, form, or lack of care for form within the work itself merely creates more parallel strings within the extant endless parallelism of the art context in particular and in general. There is no way to draw a logical conclusion about the political, moral, or ethical stance of the artist by attempting to resolve their rhetoric with what appears to have been produced. There is no moment of completion in any work. The point at which the artwork is released into a context within which it might be supposed to have some use value is not a terminal frontier—it is merely a moment when the endless parallelism of the state of art is exposed even more fully. The work at this moment becomes part of an unresolvable context, and it too exemplifies its status as a product of unresolvable drives that cannot be consolidated.

As they circle the work, the pressures of institutional, instrumental, and exchange aspects become part of the commodity aspect of the work. There is no work that can exist capable of evading this fact nor one that can ever resist the breakdown into endless parallelism.

Collectivity and supersubjectivity attempt to gather these parallels and force them to congeal through competing desires. Collectivity and subjectivity mask endless parallelism—they cannot replace or deny it. Collectivity turns the strings into clumps of overcooked pasta. Supersubjectivity pulls the strings taut but leaves them surrounded by clumps, merely creating a temporary supersubjective tension (irony).

There is no conflict between simultaneous realities and parallelism—they are perspectival aspects of the same nonresolvable phenomena. Simultaneous realities are fixed points at any moment within this parallel schema. Taking a slice at any angle—whether torqued or bent—through the parallel unresolvable strands of art will create this series of simultaneous realities but will not contradict the essential parallelism. It will merely represent it in a different form. Yet this sense of there being simultaneous

realities is especially helpful for the artist who wishes to understand the context at any given moment, and therefore it has a serious use value. For at any other moment before or after the establishment of the terms necessary to map simultaneous realities, it is possible to create a new series of simultaneous realities. Such apparent realities do not contradict parallelism nor exchange with it or replace it. The notion of simultaneous realities is just another way of regarding art within the flow of time. Thinking harder about simultaneous realities rather than parallelism enables artists to have an engaged relationship with the current context from any perspective but does not do away with the essential parallelism of varied practices. Thinking too much about parallelism restricts the ability of the artist to deploy his or her inevitably unresolvable praxis within a given context; only focusing on simultaneous realities means that the artist removes him- or herself from the realization that, while appearing with all other artists, each specific practice cannot be melded.

The context is also a series of parallels: each view of the context is a slice through a constantly fluctuating set of parallels taken from an infinite number of apparently simultaneous realities. The parallel aspect of the context is the result of it being unstable and impossible to verify—a number of parallel and necessarily conflicting simultaneous realities taking different slices from a flow of parallel strings. Nothing conclusive can be understood from the position of the parallel in regard to simultaneous realities, or vice versa. The parallel appears less *political* (activated, conscious, agitated) than does a focus upon simultaneous realities. However, neither has an ethical advantage over the other. They are both systems of perspective.

In a social model that is dominated by projection and parallelism, contemporary art has adapted and masks a deep schism in terms of analysis and action.

Art as a Pile

Split and Fragmented Simultaneously

Contemporary art is split and fragmented, and because of this it holds together against attacks both subtle and virulent and from both within and without. It is this simultaneous and constant splitting and fragmentation that gives contemporary art its strange endurance and prevents it from being transcended, at least for the time being. Contemporary art is a pile: it is essentially an accumulation of collapsed ideas in cumulative yet sometimes vigorous forms. Within this pile we have recently seen more splits than fragments. There is a distinct break between artists, curators, critics, and historians, all of whom are operating within an amoebic system of nodular subjectivities (seeing each art act as a moment, cumulative or not), and those who use documentary, research, and discourse as a way to attempt to keep alive the social and critical potential of art (seeing borders, boundaries, and paths). It is this rupture that drives most differences, disagreements, and claims for a territory of effectiveness in contemporary art today and stimulates the most profound discussions. These two positions might be represented as those who see *chains* versus those who perceive the proliferation of *amoebas*.

Those who recognize and decode chains see relatively clear borders, whereas those who are surrounded by amoebas see mainly moments, fragments, accumulations, reproductions, and secretions. Those who see chains perceive threads and connections toward a way through the pile; with the amoeba there is an accumulation of moments and meanings that float alongside one another but have no fundamental connection beyond splitting, reproducing, and enduring. The chain can bypass formal and aesthetic nuances in favor of messages, information, and communication. The amoeba amplifies minor nuances in order to differentiate, dislocate, and squeeze significance from heightened subjectivities. The chain is genealogical; the amoeba is archeological. The chain sees connections and relations in the here and now, and the amoeba sees layers accumulating where meanings may eventually be found. Neither can claim any hold over earlier discussions around identity and difference. Rupture and the accumulation—chain and amoeba—can both claim to be political and deny political agency from every perspective simultaneously.

The rupture caused by the chain puts the collective totality of contemporary art under stress. The chain sees amoebal art as an identifiable practice with its own slowly secreting, colonizing codes and unspoken repetitive values, and it rejects it. The chain tends to be more interested in the history of exhibitions; the amoeba remains focused primarily on the products of artists in isolation or loose combination. Crucially—whether chained or unchained—contemporary art lets nothing escape from its purview: once a set of ideas, propositions, or positions enters, it cannot escape. Even when a terminal border appears to emerge, contemporary art as an accumulation of amoebas and chains does not provide an escape route because of its excessive recognition of the node over the edge. It is therefore urgent to establish the origins of contemporary art and whether

it has an endpoint. What period are we in? Are we permanently contemporary? It seems unlikely.

Can we use mainstream markers to establish a way to address these questions—art history, the curatorial, the history of exhibitions, or art as activism? How about looking at the art market, the education system, collaboration, participation, and community projects? The problem is that focus on these areas alone often produces a pseudoethical competition of instrumentalized justifications and excessive reflections in the face of an always-floating-free nodal, amoebal, supersubjectivity. This results in a continued false duality: that the art context is a perfect mirror of rampant neoliberal capitalism containing no resources to counter the complete reach of a marketization of every relationship pitched against an insistence on refusal and resistance via supersubjectivity, reiterated postformalism, and the superficially political.

Importantly here we are faced by the problem of philosophy—or, more accurately, the problem of the way theoretical writing of recent philosophers is embodied in and constantly reapplied to contemporary art. Whether art is searching for borders—chains—or accentuating nodalities—the amoebal—the philosophical writings of the last fifty years are both interior and exterior to contemporary art simultaneously. They are at the base of most attempts to produce advanced art, even when barely understood by the artist, and crucially are at the base of all attempts to analyze art once it has been produced, even when poorly applied or denied by the critic or curator or artist. Responsive conclusions about aesthetics, art, and ethics formulated by philosophers are deployed as instructional or attitudinal tools for the origin of new art, which is also influenced by all the other art that is more or less influenced by philosophy, consciously or unconsciously, assertively or in denial. These artworks then filter into the writings of

enlightened or curious philosophers, who produce more writing, which produces more work and so on in a feedback loop. There is no contemporary art that can escape the circle of analysis and theory that both underscores and overwrites it. A philosophical conclusion is an artist's starting point, and vice versa; an artist's work is a philosopher's point of departure.

FOUR

1820: Erasmus and Upheaval

Certain temporal stresses point forward from 1820 and indicate genealogical strands toward an understanding of contemporary art. By "stresses" I mean moments that cause a shift in the underlying structures that shape behavior (and vice versa) in the self-identification of people in relation to other people. Some of these stresses are public and function as part of a legislature, a politics, and other mediated governmentalities. Some are technological; others are personal. All are moments where events take place that later will have general and specific influences, influences that will become more clear as I apply the issues at hand to the way an artist might consider their role both consciously and subconsciously within our contemporary framework. Taking the year 1820 as a pivot, I will outline stresses related to enclosure and the rise of national identity, specialization in the light of new technologies, the development of parallel histories in tension with simultaneous realities, the emergence of the rebel who provokes commentary within a search for settings, and the emergence of places of thought in tension with the appearance of places of display.

The year 1820 sits between the late eighteenth-century republican revolutions and the apparently limited revolutions of 1848. It was a period of partial political autonomy for parts of Latin America and saw a division of powers in Europe following Napoleon's failed attempt to create a unified continent. There was constant upheaval among the emerging and historic European states, regions, and countries within countries. Prussia, Bavaria, and the Rhineland vied for position. Further east, various city-states, nationlets, and ancient feudal monarchies existed within what was to become the Austro-Hungarian Empire. It was into this context that Friedrich Engels was born in 1820 to a wealthy family of textile producers and evangelical preachers. Larger entities were superseding the feudalist structures that had relied upon the use of common land to sustain peasant life. Engels was an atheist and the future financial supporter of Karl Marx. Before their collaboration they both wrote for newspapers, campaigning toward increased awareness via the press, common land and workers' rights being a particular focus at the *Rheinische Zeitung*, to which Engels contributed early anonymous articles. This was a period that saw the emergence of a new political consciousness requiring communication to fragmented territories just at the moment when the peasants were becoming the workers. An activated press began to campaign, investigate, and challenge authority, whether that was an emerging bureaucratic, industrial, or military authority—or the God-given authority of the State, the King, the Prince, and the aristocracy. This was an developing discourse with a voice that attempted to rouse consciousness and address the enclosure of the commons. The proliferation of contradictory territories countered by processes of technology and theories of resistance is central to an understanding of the contemporary cultural terrain.

In the United States, institutionalized relativism was the result of a desire for expansion and enclosure—geographical and interpersonal—a process

of growth that extended the territorial logic of a continent as country. The Missouri Compromise of 1820 led to a massive geographical expansion of the nation and further realized its potential for growth achieved through concession and limitation at the same time. The Missouri Compromise created a larger United States and continued a progress of expansion and enclosure at the expense of any universal moral standard. The country at that time was already politically split between the North and the South, a rift balanced by the equal number of states that supported or opposed slavery. The Missouri Compromise allowed the inclusion of the Missouri territory—which had been part of the Louisiana Purchase—without disturbing this balance. In return for slave-state Missouri becoming part of the nation, antislavery Maine also joined in order to ensure a continuation of injustice via a numerical balance of representatives in Congress.

Missouri was one of the many compromises that took place between the American Revolution and the American Civil War and that contributed to an acceptance of different values in different geographies, territories, and mentalities within a notional unity. The compromise reinforced a North-South divide. The Missouri Compromise wrote into law the idea that there are fundamental social, political, and geographical identities that are trapped within territories: the idea that in some places the slaver was the essence of the way things are, the way things have always been, and the way things will have to be in the future. The slaver was against unity yet accommodated by unity, and he was an exception to universality given his use of human beings as possessions and tools. The accommodation of moral relativism within a contradictory legalistic framework had been set into play.

This sense of mapping expansion with caveats can be traced in other ways. The HMS *Beagle* was launched in 1820. Certain materiel—shipping, weapons, and new control equipment—continued to be produced in the lull following the end of the Napoleonic Wars and the emergence of an

idealized balance of states. The ocean-going ship was an example of excess production, something temporarily beyond requirements. The emergent amateur scientist appealed for the use of that excess. So it was repurposed—deployed for a new role of research and exploration—with Charles Darwin sailing on its second major voyage in 1831. Exploration and research are the scientistic forms of colonization. The ship sat at the heart of exploratory scientific work and was the carrier of new forms of British empirical scientific development. The ship as excess provided a home, location, set of tools, and vehicle for the notionally amateur. The scientific explorer was involved both in a series of breakthroughs and functioned as a new model of soft imperial vanguard, one interested in the understanding and exploitation of natural systems and armed with collection nets and boxes. It was no longer a question of sailing off in search of someone else's land and planting a flag. Instead, scientists arrived and engaged in activity that appeared nonpossessive but was complete in its desire to catalogue, collect, and comprehend. Systems were being created. Specimens were collected and the land examined in detail—all masking the deployment of overt power structures. The idea of research as an empirical activity relied upon repurposed tools of authority yet was to produce insights that obliterated accepted hierarchies.

It was not only the future use of a surplus ship that embodied apparently soft action and revelation in isolated locations. In 1820, Joseph Smith had his first vision toward the establishment of the Mormon Church. By creating a founding myth to match the emerging confusion over political and interpersonal control systems, Smith found a way to materialize a commune that would follow a new direction given by God. A vision was at the center of his conceit, and thus it was crucial in the context of examination and impartial scientific exploration to describe the vision. A mixture of the empirical and the visionary went together—they were

both modes of discovery. They shared their languages of discovery, break-through, and revelation. Both created a crisis of evidence, faith, and belief. Those dismissing the vision could be accused of believing in science, with circular arguments positing science as an opinion and the existence of faith as a fact: *there are people who believe.* At the same time, the Darwinian researchers struggled to accommodate their discoveries within the frame-work of the 1801 draft of the Thirty-Nine Articles of Faith. The *Beagle*, the Missouri Compromise, and Joseph Smith's first vision were differ-ent aspects detailing the construction and control of domain—territorial, scientific, and divine. The creation of unique behavioral codes would be determined by context.

As Smith was having his visions, the *Venus de Milo* was found in a field. Unearthing at this point was already linked to scientific research. Literal unearthing was a way to be astounded and confirmed by the past. The unearthing of the *Venus de Milo* is a miraculous material vision—it established a relationship between the peasant laborer on the land and the potential legitimacy of the emerging modern state. The peasant farmer who unearthed beauty brought it to the attention of cultural/military agents of the state for advice and safekeeping. The militaristic cultural agent was the relative of the Darwinian researcher—claiming, removing, and redistributing models of antiquity rather than information to the cen-ters of power. The *Venus de Milo* and many other nineteenth-century dis-coveries produced a battle over the future location of the antiquities that had been unearthed by the humble act of tilling and plowing. Propaganda value vied with monetary value during the battles over the possession of simple discovery. An increasing recognition took place around the value of heritage and the nationalistic capital of those working the land—people destined to unearth their patrimony and thereby reinforce an emerging set of values that heightened the legitimacy of emerging postfeudal states.

There is a link here to the tension in the Missouri Compromise, and this is a skepticism of any given nation's ability to care for the implications of its emergence. Cultural battles developed between different states. The invasion and reinvasion of a country was no longer restricted to rough plundering but became a developed scientistic version of the same—the removal of something through intellectual scientific justification framed by claims for better care and knowledge production. This was contextualized by the development and consolidation of geographical societies and various other research organizations interested in preserving antiquity—in tension with their emerging construction of national power. Particular objects would became associated with philosophies of national identity.

In 1820, some technologies were enacted, and others were restricted. It was the beginning of a recognizable understanding of the dangers and potentials of progress within a context of rapid development and discovery. There was an increasing understanding that something would work in practical application at some future point, given the correct materials. There was a growth in the ability to perceive the slow development of applied science and to demonstrate that something will be applicable on a general level once a practical solution can be found. The first light bulb using a vacuum tube dated from 1820, predating Edison by sixty years. The problem was the necessity of using platinum parts to create the filament, and this made no financial sense in broad application. Yet objects were reaching forward: they were proven to work. They just had to wait for parallel developments. This created a new sense of certainty in the direction of technology and the emergence of development itself as a trajectory. There was an increasing faith that there would be another way at some point. The breakthrough was increasingly reassured by projection, development, and application of an idea. Technology could now be viewed as moving in incremental steps and jumps. Patent law—drawn up by the U.S. Congress in 1790—would protect

work while creating motivations for breakthroughs. A tension within the idea of protected development caused an infinite splitting of innovation. Multiple protected strands of technology started to appear, all functioning in parallel. Tiny steps protected by patents combined with the expectation of future growth, application, and profit (at some point); in tandem developed the motivation to innovate *and* a desire to control patents for original work as something valuable in their own right. The notion that an innovator has a specific language and history that requires analysis, protection, and understanding in context had arrived.

Incremental development was shattered by moments of revolt. This was particularly true in hotspots of technological application, such as Glasgow. The year 1820 saw the Radical War, also known as the Scottish Insurrection. This was the last true armed uprising in Scotland against English domination. An awareness of inequality was masked by contradictory drives that claimed fidelity to nationalist identity and outward respect for the center of British power in London—a desperate appeal to the reasonableness of indulgent strength. The Radical War carried a number of mixed messages, some of which were connected to the emergent idea of nationalism as an ancient identification in tension with acknowledgment of the God-given authority of Empire and Union. The revolt was caused by the economic depression following the Napoleonic wars yet was viewed as simple treason against the enclosing state. This uprising in Scotland against the union masked a struggle for workers' rights. Strikes took place in the newly dynamic industrial contexts of the Clyde River area and in parts of Edinburgh. The rhetorical devices deployed by the radicals were the same ones to be used over and over again during the subsequent thirty years leading up to 1848: rights, liberty, or death. Uprising and radical war was connected to the development of mass labor organizations in opposition to the central militarized bureaucracy and industrial production.

The collective struggle of these very early industrial workers may have been masked by broad appeals to nationalism, liberty, and universal rights, but at the center of research, compromise, and revolt was the emergence of the conscious radical and the romantic ideal of a doomed figure as the political agent within temporal stress.

By 1820, an emergent class of innovators and entrepreneurs had already intermarried with early industrialists who also came from non-conformist religious backgrounds and deployed scientific work toward applied production. This intermarrying allowed innovations to flip back and forth between production—for example, the ceramics produced by the Wedgwood company—and scientific research. Production was a site of development and created capital to fund amateur exploration and research. There was an interlinking of theories of human development and the progress of industrialization. This was combined with attempts at a practical scientific philosophy in order to understand descent and progress and the way these two concepts might feed into the development and growth of capital, innovation, production, technology, and exchange. The visionary, the entrepreneur, the antiestablishment figure, and the scientist were increasingly linked.

What are the bounding ideas and concepts that these temporal stresses secrete into contemporary art? First, the development of parallel histories in tension with simultaneous realities. Parallel histories allow competing narratives to be understood without being resolved. Parallel histories operate on top of one another and appear to intersect from some perspectives but actually function as curled strands rather than fixed trajectories. A tension between simultaneous realities and parallel histories is already visible in 1820. Parallel histories tend toward the discursive rather than toward a cataloging of objects. What becomes possible is a necessary paradox involving the acceptance of the simultaneous existence of things at any

given moment in tension with the trajectory of ideas cross-sectioned at any given moment. Where things sit versus how they relate to one another. Parallel histories require an awareness of how people use people, and this was heightened by emerging forms of life, labor, and work and the tension created between people coming together with collective interests and in resistance to the progress of industrialization. The mapping of how people use people was part of a growing set of awarenesses. There was a development of humanist empathy, brother and sisterhood, and the construction of various societies in the gap between the French Revolution and the revolutions of 1848. The notion of inclusion and exclusion within a process of apparent liberation and expansion was being reflected and operated upon by new semiautonomous groupings. The idea of strategy emerged within these nascent societies, organizations, collectives, *and* calls to revolt.

Closely related to parallel histories was the rise of the secondary individual, those who escaped the limitation of *their place within the hierarchy*, in relation to the family or emerging constructions of the social in order, to engage in science and development. The arrival of advisors and assistants included those who carried out specialized tasks and were to become part of a broader think-tank of secondary specialists. The secondary individuals were the ones who actually did the detailed work. Free thinking drove them. A structure was constantly sought out. Free thinking also required locations, places where it could be, places either imagined or posited just out of reach: an architecture, a locale, or a sense of association. This search for a location emphasized the fact that free thinking could not be stabilized but would constantly require relocation and reassertion. It was not possible to imagine sites of free thinking separate from their unstable architectural coding. Architecture had started to carry ideology in flux. The relationship between architecture and emerging technologies was stressed and disguised. We were at the beginning of a camouflaged architectural anxiety,

where the certainties of classical references started to break down in the face of the requirement to accommodate new technologies and control systems. Classical references were beginning to be stretched over pragmatic diagrams—later toward an attempt to submerge all iron in a Gothic overcoat. As we reached forward into the Victorian period, architecture floundered to find the right historical reference points to make sense of technological development, so it showered it in references instead.

Protosociological research ran alongside this emerging class of secondary specialists. The Malthusian worry about the planet and human survival expanded via an increasing understanding of conflicting trends and directions among humans—parallel histories versus simultaneous realities—all connected to developing political philosophies in tension with early industrialization. Technological development faced the desire for rights despite the God-fearing and sometimes indulgent capitalist in tension with progress and efficiency and the increasing use of workers as human machines. The secondary individual quietly spearheaded development and technological advance. Free thinking and the endless search for its locations produced a protosociological domain worried about the future and starting to plan and think about the city and its occupants as aspects that might be improved in line with emerging political philosophies. The struggle for rights was moving toward the universal through the articulation of specific grievances.

But not everything was locked into an urban frame. Discovery and tour were part of the larger control framework that included peasants moving toward industrial centers and the new specialists leaving in pursuit of early humanity and ancient art. This search for beauty and the classical ideal continued at great pace. Archaeological finds were displaced to the new centers of power, where they could be emblematic of the potential of democracy and culture as profound constructions. The focus on the unearthed as the

epitome of the human ideal left the processes of the present free to carry out masked upheavals. One set of people claimed and decoded ancient cultures, and at the same time there was an equal movement in the opposite direction, toward the city—toward the factory and the imminent grind of human against machine: a constant tension between the desire to find sublime beauty and ideals in the ancient world and a necessity to reflect upon the upheavals of the time.

None of this can be understood without including the growth of ecstatic new religions and institutional superstitions. The desire to create parallel histories—new ancient parallel histories—may have produced completely fictional accounts, but they inspired faith by appearing no less incredible than any other discovery—no stranger than the artifacts that were being dug up as a result of tour and discovery. An apparently endless set of stories was waiting to be revealed. Claims might not be verifiable, yet they nevertheless were brought back to the center and structured into fabricated superstitions that would inspire new faiths to match new territories. This was a time of competing claims for textual authenticity—where the stresses of the *Republic* and *The Rights of Man* came into conflict with an adherence to new supernatural texts.

How can these traces be found in the persona of the contemporary artist; their support structures, both critical and physical; and how the work itself is produced? Using 1820 as a point of departure, where do I see the application effect of these various ideas, and how did they become embedded in the culture over nearly two hundred years? What legacy, what framework, did it leave? How did it shape the way contemporary art is currently formed, and how does it demonstrate its various permissions and structures?

Beginning in 1820, structures were set up where people began working at different speeds toward different ideals. Forms of emancipation opposed

development and technology, setting up a conflict between various techniques of control and expression. In the struggle to realize various nation-states, a growth of critique, criticism, collaboration, and the discursive both produced and resisted these processes of enclosure and establishment. Production, the production of conditions, potentials, and desires, was more developed than consumption. Consumption was already an awareness, but its mass function could not be realized in a postfeudal environment. Production was countered by the defense of the commons—of common land in particular—rather than by a developed critique of consumption. The journalism of Marx and Engels campaigned in favor of the right to maintain the use of common land and against the appalling conditions of early industrialized textile workers. All this was connected to new understandings of the way a set of objects or ideas might be put into action and find a use, a sense of looking toward how technologies will be ameliorated rather than how they will be consumed.

New developments in production required demonstration and display. The exhibition became a site for presenting both artifacts and technologies. The early museum and trade exhibition were both linked to the transcendent and timeless aesthetic values of the fine arts. No technology was divorced from a desire to associate with notionally high aesthetics, and the emerging exhibition linked technology and architecture to beauty, creativity, and rationality, combining examples of fine art with the appropriated discoveries of the ancient world. The exhibition was soon to become an entity in its own right, one that would need to be filled by new forms of production. The exhibition was an emerging demonstration of national desire and something for which artists started to produce work. It was not merely a place of display for what had already been made. The object of art would become integrally linked to the new sites where it could be enacted and considered in its own context.

This consciousness of display was connected to the continued development of sites for free thinking. The artist required a special set of places. The rise of the secondary individual within an awareness of how people used people contributed to the establishment of these settings and places of free thinking—including the continued proliferation of societies of specific groups or specializations. This socializing took place in tension with the improvised zones of the revolutionary and the rebel in relation to the broader strains within emerging industrial states. The rebel mob no longer operated alone and without commentary but instead engaged sets of people who started to gather and theorize emerging radicalities beyond the limits of religion, although often with its formal languages and references. The establishment of settings and places for free thinking operated in parallel to the development of the exhibition. Convivial places of exchange—the café and the beer hall—were locations where the secondary individual started to roam free of all structure outside of the contingent self. They could not be separated from a political consciousness or radicality in their sites of thought. This dichotomy between sites of free thinking and technologies of display resonates and leaves an embedded set of values within contemporary art. The battle between free thinking—or emerging criticality—and modes of display had been enacted.

Populating these contradictory zones were characters rather than objects—figures who worked in tension with one another and who fluctuated in dominance. It takes an understanding of this gathering together of a series of characters—a band, a troupe, a grouping, a confederation of people—in order to understand later developments. Ideas emerged from contradictory groupings. This has led to a permanent population of the spaces of art with historical phantom artists rather than verifiable historical reference points. The contemporary artist is always joined by a series of characters who emerge just before the uprisings and revolutions of 1848.

The notion of playing out the role of an artist has become deeply embedded in this historical scenario. To be an artist is to be convivial with history; it is not a branding of the self in relation to the production of objects.

The act of looking backward toward antiquity to justify the sense of the state as a true preserver of history was countered by the rebel, the loose group, and the underground society: the free thinker and the proto-artist working in parallel with the secondary individuals who would do the collating and close reading. These were the specialists who would operate under, within, and onboard the surplus production of an Empire, specialists presented as permanent amateurs cowering in fear of their own concepts. The year 1820 creates new settings and creative populations all capable of infinite potential actions, populations caught between preserving ancient rights and resisting new technical trajectories of modern life. The artist as a contemporary figure has not yet been produced, but the support structure for his or her social function has been set out, and various potential parallel trajectories are mapped and waiting. A casting session is under way to find a character who can function in the spaces between faith, reason, and desire.

ASAP Futures, Not Infinite Future

I t may be more functional if we mobilized these concepts toward the day after tomorrow rather than toward the infinite future progression of self-improvement. It may be more useful to operate with short-term projections without thinking about them within the ideology of pragmatism, a marked pragmatism, but operating more within the notion of intellectual *work*. This is a very subtle shift. Worrying about whether an artist can be good is not what should be at issue or in question. We should be curious about the quality of the work in the near future—the quality of its critical function. There should be a desire to transfer the critical dilemma into an imminent, temporal space rather than to defer it into the dysfunctional infinite.

You find that a lot of structures within the art world veer toward the idea that the default state will be an endlessness and infinite projection. The suggestion here, then, is that ASAP is more positive and problematic than infinite projection. If you defer continually, nothing happens, nothing changes. Everything will be fine, but you will flounder within a state of permanent projection. The difference between projection and displacement is political. One model accepts things the way they appear to be; the other

moves things around to find a better arrangement. Displacement always differs from projection. Projection is always either supernegative or superpositive, in the sense that it removes the subject from immediate action. It is the speculative tool of choice. So we should be more interested in reclaiming the speculative as a critical problem and using displacement as a tool toward taking it apart. The speculative is a concrete version of projection. Dialectical positions have to be affected by pleasure and psychosis. There are necessarily some human qualities in play here that are not pure. Look at people's behavior in an educational environment, and you can see that they often become psychotic, or they become pleasure seekers— because of their desire to continue an endless dialectical relationship with their own projection. After that, it is all just industry and intelligence.

1948: B. F. Skinner and Counter-Revolution

The year 1948 brings European nationalization of industry and the rise of the corporation, new relationships between the individual and the group, the application of advanced modernism and the emergence of containers for identity, and expressions of dystopia and material facts in the face of art's deployment by capital and the social.

In Europe, extensive nationalization of industry was the predominant form of the reorganization of labor in the immediate aftermath of World War II. The nationalization of the UK railways was a highly visible example: the unification of a system under a graphic regime. Nationalization was part of the attempt to build a new European model in a unifying light following the devastating experiences of war. The collectivizing of industry under state control—and in the United States the supposed patrician tolerance of the mature corporation—took place for clear ideological reasons but was affected and enabled by the perceived success of state-controlled production during wartime. Nationalization was a collective container for bargaining between postwar labor movements and governmentalities—organized labor engaged in collective bargaining. A few people sat down

in a room with politicians and corporate heads to decide the fate of entire industries. Various degrees of singularization were at work here, bringing people together under new codes. Single figures as points of resistance communicated with simple straightforward voices. The unification of systems under a contradictory political set of urgencies is central to our contemporary terrain of fundamental contradictions.

A process of decolonization and independence shook the emerging reconstruction of industrial nations. It is useful to look across from this time of nationalization and collectivization toward a moment of catastrophic symbolism that also related to the construction of a new unity. The assassination of Gandhi occurred in the course of a struggle for independence: the sacrifice of a single point of resistance who had worked peacefully toward an abstract national unity. Violent resistance had been constructed around a passive core in the context of many attempts to assassinate him. As with the nationalization of industry, people were being brought together to create contingent identities. With Gandhi's death a single figure became embodied as a passive point of resistance toward the collective. Processes of singularization and collectivization would remain in permanent tension.

In 1948, the Soviet Union decided to jam the Voice of America radio station in order to prevent the communication of negation. Growing up in Europe in the 1970s, Voice of America and Moscow Radio were both on the air. They both presented soft propaganda that claimed to be reasonable and sober. They both used the language of peace and claimed to occupy the moral high ground. They both established and maintained a set of facades. They presented universal truths that were unresolvable. Their broadcasts were parodies of rationalism, excessive claims of deployed pseudorationality beyond the contingencies of everyday life. This set into play a situation where it might be possible to be profoundly insincere while utilizing

the highest ideals toward the edge of human existence—to the verge of annihilation.

In the face of so much sacrifice, reformation, and presentation, some proposed new resistant collectivist ideas in precisely coded ways. The Hell's Angels, a grouping of apparent outlaws, were founded in 1948 as an antidote to these processes of coming together. The Hell's Angels were immune to the postwar founding of institutions and the reorganization of industry. "Hell's Angels" was a term inspired by the cartoonish naming of planes during World War II—a pepping up of spirits through a graphic ecstasy of individuality, liberty, and autonomy, messages that could only be read while on the runway or after crashing to earth. The Hell's Angels first appeared as rogue bands who were outside of the system, and they explicitly demonstrated their outsideness: their rejection of a bourgeois life, their literal disruption of a peaceful America through bluster and noise. Their appearance was frightening, their presence disruptive and ungrateful. They brought catastrophe and brotherhood back home from the front as a posturing, languid, motorized libido that had no function other than to be free and in opposition to everything but its own complex codes.

The deployment of radical machinery was not limited to the Hell's Angels. In 1948 the Land Rover was introduced, and Porsche was refounded as a postwar sports-car company. These two events pointed toward the development of specific vehicles as tools, a clear specialization emerging from the war period and searching for a new distinction in peacetime. The Land Rover was soon to be used as a tool in the fading colonies as much as it was to be found on the farm; it presided over the processes of decolonization and mobilized the landowner. The Land Rover was perfect for new markets that desired reliable, flexible, useful control tools: the specialized deployed against the group. Porsche was a reestablishment and continuation of the prewar Volkswagen company rendered special, outcast, and

now given a real family name, in order to work in the open and finally take responsibility. Specialization here was connected to emergent branding and for the first time disconnected from class identification in a traditional sense. These vehicles were primarily offshoots of militarization and the overdetermination of the racetrack; both were symbols of work and action. They both had a utilitarian, pared-down quality within clearly identifiable and defined forms. Shortly they would become the vehicles of TV naturalists and rebellious film stars.

Other specific technologies emerged in 1948. The long-playing record was intended to be the ideal replacement for the clumsy collections of short-running, fragile, 78-rpm discs of classical music. The LP record had originally developed as a technology for film—being the same length as a single movie spool—but it quickly moved into a widely distributed medium, its cover becoming a popular container that would be central in the development of youth culture and various subcultural identities. Quickly the cover began to float free from the record. People would soon spend a lot of time browsing and reading the covers alone, which is how the albums were displayed in stores. The cover was a place of design and identification. This was a period when the container was becoming as important as the content. The year 1948 also saw the development of products that would later be associated with the container of the industrial-military combine—including NASA. The myth is that these products were brought to us as a result of innovation within the military. Velcro—for example—was simply an attempt to use petrochemical products to replace simple consumer items. Making the easy easier. It was not the military that invented Velcro. This innovation was merely purchased in large quantities by the U.S. Army. It was this bulk ordering that created a link in the minds of people between consumerism and militarization; military spending was a consolidator of innovation, not a producer. This was a period of crossover between minor

innovations—fixings, fittings, and surfaces—and the industrial-military complex. All started to connect in the mind of the consumer from this point onward.

If the temporal stresses under consideration here primarily relate to the tension between the singular and the general—the individual and the group—it is unsurprising that behaviorism was a key area of study and development in 1948 both feeding and analyzing these processes. There were many attempts to examine, control, and apply ideas from psychiatry and psychology to large groups of people, both to investigate individual desires and to try to account for these desires in relation to larger populations—B. F. Skinner and his book *Walden Two* being the most widely distributed.[1] Yet accusations of utopian thinking had particular resonance in a period that had suffered so heavily in the recent past from war—perverted, accelerated attempts to reach utopia had resulted in mass slaughter. Soon after a conflict that had revealed fascism and state communism as mutant utopias we saw in Italy the first and last rise of electoral communism in Western Europe. Yet in contradiction to the agonies of war, this was an attempt at a rapid activation of incremental utopias rather than totalizing systems—nevertheless, the CIA thought it prudent to fund the opposition Christian Democrats.

The project of the prewar Bauhaus and other European forms of modernism restarted in this immediate postwar period. Places had to be rebuilt—Rotterdam, Coventry, Dresden—and they required new forms of organization. Europe had to be reimagined, and the connection between modernist architecture and planning was crucial to this process, with planning moving into a primary position. This shift was profound in relation to contemporary art's genealogy. The object was no longer operating in isolation. The application of modernism was once more connected to planning as much as to the attempt to produce an autonomous object.

This was a dynamic time for the development of social models intended to give people a better life. Architecture was seen as a way to achieve this. A process was instigated that could be described as the Ulmization of the Bauhaus legacy—an accommodation between the utopian legacy of the Bauhaus and the contingencies of the emerging nationalized industries and corporations with the Hochschule für Gestaltung Ulm—the Ulm-based industrial design school researching and developing new efficient buses, graphics, and structures.

As modernist architecture and design shifted toward planning as part of a necessity, it also became integrally linked to an emergent corporate environment as the state began to function as a corporation and as the corporation as an applied idea increasingly matured into something too big to fail—but that could see you through to retirement via a promise of leisure toward a peaceful and rewarding death. Both the corporation and the state turned to modernism for architectural answers. Both turned toward a related set of aesthetic values embodied within applied modernist thinking in order to project ideas. This created a fundamental rift within modernism relating to how it could be deployed against the ravages of modernity as an ethical or resistant tool. Late modernism was being used both negatively and positively. The object in itself was no longer the most important thing. The act of clearance—how things are cleared away, the necessity to clear things away—became as important as the idea of actually building specific technologies.

There was a drive to create a better society—or a society in the first instance. Society became a subject in itself, society as defined by its social programs. An expansion of democracy was part of this process. Varied attempts to eradicate poverty and create *a society* through the combination of consumerism and social programs vied for dominance in the noncommunist states. In this context art became increasingly symbolic of an escape

from such tense developments but also became its backdrop, not only for advanced progressive social programs but also for the emerging consumer figure. At this point art remained primarily idealized, but it left us with a paradoxical legacy. Art was something for society on one hand; it was connected to the idea of society as a development, but at the same time art began to operate as a backdrop to new forms of advanced consumerism. The advanced postwar corporation started to exhibit good will, taste, and agreement with the idea of social development via the deployment of art as an acceptable backdrop for varied activities. Culture became something to be invested in without question.

The project of creating a postwar society involved an examination of behavior and attempts to mold behavior through planning, schooling, and architecture. A key aspect of behaviorism was its connection to the emergence of ecoconsciousness. A link began to form between the individual as an active subject and the ecology. Part of the process of general education became the changing of behavior toward creating better places. This process was connected to the collectivization of people within nationalized industry, corporate life, and the interface between the individual and the new state/corporate identities. The education of the subject/pupil within the new modernistic architecture of schools, clinics, and kindergartens started to produce a generation of children whose role was to educate their parents—an inversion of education. The responsibility was to be conscious. A reorganization of individual behavior went hand in hand with industrial production and with finding ways for the war economy to be extended beyond conflict. The state control and corporatization of industry created the new union dynamic of collective bargaining, where everyone was in the union and where everyone was fought for under the same terms. At the same time, we saw the continued attack on union power as it became a singular entity balanced by the corporate/state opponent.

The unions' solidarity became a problem. And outside these simply drawn binarisms we were left with art as a massive liberatory field to play in: a set of expressions, a massive terrain of creativity and truth marks that could grow to include almost anything overlooked by these monolithic concerns.

A fundamental rethinking of education emphasized the idea of the kindergarten as a model, creating a mixture of health and education. At the other end of schooling was an increasing universalization of secondary education in industrial countries, which started to produce mass identities and shared concerns. Some concerns were internationalist and universal, for example, ecology and consumerism. All of this emerged just after twenty million people had walked home all over Europe. There had been a massive displacement. These unifications and singularizations were confronted by the return of wanderers—the return of the dead, in some cases. The people who returned were ready for something better. Those walking home were met by trials over the recent horrors, public trials involving the unraveling of information and ideas via the seemingly rational depositions of the participants, trials held in order to have a deeper understanding of the behavior of the recent past—to find out who was responsible and who could be accommodated.

These bounding ideas were extremely deep rooted and left strong traces in the way art can be understood during the postwar period. The constant struggle with the idea of utopia—utopia as an accusation and the necessity of the artist to reveal utopia for what it is: a warning and an endless desire. Art started to function as a process that reveals the dystopian. At the same time, it presented an illusion of what could be. Something that might evade hierarchies—evade claims to the auratic—somehow merely posit objects, materials, and activities in space and make simple universal claims. Art became connected to a democratization of society where an individual's work was the product of some work and nothing more. Art as

a process of making art. Art as a part of society: society as a developing idea and art as part of that developing idea. Yet, of course, this is the point when art started to become something that was literally a pile of contradictions sitting between consumerism and social programs. Yet we are left with traces that suggest that art is a product of behaviorism. That the behavior of the artist—his or her role and function—is connected to some sense in which we understand that the artist is revealing something about a constructed notion of society: he or she is showing us how to see how things go together and what remains once everything is accounted for.

The reorganization of industrial production left strong markers within contemporary art—the idea of fabrication in relation to Taylorist practices combined with the notion that in order for art to deal with the present it also had to take into account new modes of production, modes that today extend beyond the industrial fabrication of objects and toward the production of new systems that critique, affect, and influence behavior and desire. Art has been taunted by the idea of collective bargaining; contemporary art can be understood psychologically as a form of collective bargaining. A pile of differences operating under a general system. The rethinking of education with the kindergarten as a model affected everything in the sense that it changed the way artists speak. It altered their modes of expression, forms of communication, and types of organization. The artist became a person who must be an exceptional citizen who speaks a rare truth of sorts to the quiet breakdowns engendered by managed societies. Transgression was for the service of society as a whole—it pointed out hubris—and put the idea of society on trial.

The film *A Matter of Life and Death*[2] is a key example of the confrontation between modern technology and utopic humanist desire. Airman Captain Peter Carter, played by David Niven, is going to have a brain operation following the crash of his flak-damaged plane into the English

Channel; simultaneously he is experiencing a dream/vision of a heavenly trial that parallels the surgery. In the trial we see him fighting to stay in a very human, flawed, and mortal world with all its failings yet with many potentials as a postwar applied utopia where things need to be done following lessons learned. It is this doubling and flickering where we find the idea of the artist as someone obliged to posit new zones of moral confrontation within a dream space but also obliged to deal with realities and understand psychology, behaviorism, and the creation of aesthetic pathways—materialities. All this was linked to new understandings about how the brain operates and how it could be operated upon. The visual was something that artists began to point out. They made you aware that you were looking at something, but at the same time they were taking you to a psychological trial such as the one we see in *A Matter of Life and Death*: a battle between the dream state and the material.

When you point forward from 1948, one of the first things pushed into place is the use of art as a location for discussion and action. Specific settings proliferate. Art can be used to take over any space and make use of any place in order for discussion and action to emerge. Everything is being renewed, and therefore art can move in and reoccupy the spaces that have been left behind or abandoned. We start to have a feeling that art can move freely through time; it is not bound to its moment. It can be a manipulation of the present in the form of projection both forward and backward, with an understanding of an increasing capitalization of every moment. With the rapid development of industry, the application of military attitudes and organization to peacetime, and a focus on behaviorism (trying to produce better people), there follows a manipulation of time—a desire to become more authentic and more synthetic simultaneously.

Art continues the prewar process of looking at historical models and starts to project both forward and backward, studying elemental

cultures—spiritual, humanist fundamentals—but also yearning forward toward the creation of backdrops for new forms of human behavior. Art deployed things that worked alongside the collective consciousness rather than in advance. It was no longer avant-garde; it now sought out applied utopian settings. The first edition of the *documenta* exhibition in 1955 was a good example, where a whole city became the venue for artistic events, including a proud turning of attention toward the work that had been included in the Nazi Degenerate Art exhibition in Munich during 1937.[3] There was a strong desire to create flexibility and to seminarize the spaces of art. This was connected to immediate postwar collectivization on one hand and the extension of behaviorism on the other. At the base was the idea of education as a permanent component of an artistic practice. Whether that was the self-education of the artist, including unlearning, or the education of the public—teaching them processes of unlearning. Art was no longer a question of enlightenment. The exhibition was a location of seminarizing and education. This was intimately connected to the rise of statements and phrases. The rise of statements by artists and curators and their introduction into education has become formalized today in the constipated self-accounting statements and phrases artists are expected to deploy in order to contextualize and educate about their own practice— both educate themselves and others—but they began with good reason and were deployed toward the construction of a new society. The desire for universal education of the individual led toward the idea of being included or excluded, and this became a strong ethical component of contemporary art: the power of the silent member or the passive participant within the group who examines the idea of inclusion and exclusion. The artist became someone who functions in order to take part in rather than to proceed toward. A sense of taking part in something rather than proceeding toward something is a factor of contemporary art. Participation is articulated through a

desire to create spaces of subjectivity, a desire to expose the studio and the studious alongside the seminar, coupled with an awareness of the difference between an audience and a public.

In the face of attempts to overwrite differences there was a necessity for the artist to demonstrate his or her artistness through his or her working method and ability to self-educate. This desire to create spaces of subjectivity was linked to an urgent need to build a better society straightaway. Having seen the failure of the totalitarian utopian, it was necessary to create various applied utopias that might transcend the decision-making limitations of politicians, committees, and groups—proposing instead excessive articulations of subjectivity. The artist in this case was primarily the person with a studio rather than the person who produces A, B, or C. In the twenty years after 1948 we were faced with a constant battle over the studio, including the studio that cannot be seen; the studio that remains permanently hidden; Duchamp's studio on Fourteenth Street, which remains unknown; the studio as an escape; the studio as a fabricators' workshop; the studio as a factory; the studio as a place where not much happens; the studio as an occupation of territory; and, most important of all, the studio as an assertion that one is still an artist.

There was a pressure to account for work. This had to do with the idea that art was about self-improvement but that it was also connected to social shifts: the sense that there would have to be change. That it might be necessary for the artist to account for his or her work in advance of other people's understanding. That there would be no fundamental understanding without the statement. And now we end up with a defense of art as a place for the creation and dissemination of content and a hyperfocus on nuanced ideological claims. This defense of art as a place for the dissemination of content is not the same as the acceptance of art as a thing in its own right. A visit to a museum or gallery is now a time to

find out something even as we experience something—the two notions have merged. There are many ideological claims in any given exhibition, but these must be viewed in light of a situation where explicatory claims will only lead to more questions around the construction of the social. Within this sense of the social—within this sense of responsibility and subjecthood—come many different nuances, and it is these nuanced ideological claims that are synthesized in contemporary art. Contemporary art became the ultimate site for detailed desires. It became the ultimate site for a fragmented creation and dissemination of content. Art is the production of sites for collective microexpression. Even the space of the advanced journal and of the resistant collective comes from this melding and muddling up of the humanist, behaviorist, and educational as inextricably linked to artistic practice. Whenever the artist tries to escape such a warm cage, further education will be required to explain how they have escaped. Meanwhile, artists who refuse to take responsibility find plenty of others to explain how their "new outside" actually furthers the process of understanding the machinations of society—and, therefore, they too are absorbed within contemporary art.

This dynamic moment of social rebuilding, planning, and clearing led to the idea of an artist's mode of work being variable potential places of work. New models of how to do something became central, including the improvised takeover of any space temporarily. The exhibition became the any space. The idea of the artist as someone who openly demonstrated the desire to retain spaces of subjectivity in places that ran in parallel to other production methodologies led to something akin to the production studio of cinema and television—of a small factory—or a place for casting characters. The work itself became the characters who needed to be deployed toward the population of the gallery, the museum, and history. Following this period of behaviorism and social rebuilding—and what in

Europe can be thought of as the period of social democracy—we were left with the sense of an artist as someone who deploys stresses that define differences, difficulties, and apparent contradictions. The endurance of the studio as a place to escape to and from demonstrated to society that it had room for such activity. By the 1960s, we saw the legislated provision of artist's studios from London to New York. The fight over the studio as an idea and whether it was the right place to be included a testing of other models of production within the artistic sphere. The studio itself became a site for and subject of experimentation and a designated protected zone for a practice, a place for the creation of permutations—questioning desire and behavior and assumptions through the filter of a practice within the microutopia of the artist's working place: a trap and a semiautonomous potential. Something to be escaped to and from.

Abstract

By making the abstract concrete, art no longer retains any abstract quality; it merely announces a constant striving for a state of abstraction and in turn produces more abstraction to pursue. It is this failure of the abstract that lures and hypnotizes—forcing itself onto artists and demanding repeated attention. The abstract draws artists toward itself as a semiautonomous zone just out of reach. It produces the illusion of a series of havens and places that might reduce the contingent everyday to a sequence of distant inconveniences. It is the concretization of the abstract into a series of failed forms that lures the artist into repeated attempts to *create* the abstract, fully aware that this very act produces things that are the representation of impossibilities. In the current context, this means that the abstract is a realm of denial and deferment, a continual reminder to various publics that varied acts of art have taken place and that the authors were probably artists.

The creation of an art of the abstract is a tautology. It cannot be verified independently. We have to accept that the concretization of the abstract is a record of itself. It points toward something that cannot be turned into

an object. But there—in front of us—is this nonexistence. Even further, this nonexistence in concrete form can take up a lot of space, supposedly pure color and variegated form. The grander the failed representation of the abstract becomes, the more striking the presence of failure, at the heart of which is a very human attempt to capture an unobtainable state of things and relationships to the unknowable. The abstract in art is a process of destruction: taking what cannot be represented and forcing it into an incomplete set of objects and images that exist as a parallel lexicon and that form a shattered mirror for what cannot be represented. There is nothing abstract about art that is the result of this destructive desire to create an abstraction. It is a process of bringing down to earth what continues to remain elusive. It is this search that connects the desire to create abstraction with utopias and is at the heart of its neoromantic ideology. It is the basis of the symbolic politics of abstraction and its parallel course as a marker of hope and ultimate failure. It is the process of attempting to reproduce the abstract that causes the truly abstract to retain its place just out of reach.

The abstract, therefore, in the current aesthetic regime, always finds form as a relational backdrop to other activities, terrains, and interactions. By destroying the abstract via making it concrete, the ambient and the temporary are heightened and become an enduring associative abstraction that replaces the lack in the artwork. The abstraction that is produced by abstract art is not a reflection of the abstraction at the start of the process. The making of a concrete structure produces further abstraction—the art object in this case is merely a marker or waypoint toward new abstraction. Tackling the job of producing something concrete through a process of abstraction neither reproduces abstraction—nor does it provide us with anything truly autonomous. It produces a lack and points toward further potentially endless processes of abstraction. It is this potential

endlessness—that remains productive while reproducing itself—that is the key to the lure of abstract art. The procedure of producing abstract art does not fill the world with lots of abstraction, despite appearances to the contrary. Instead, it populates the space of art with an excess of pointers that in turn direct attention toward previously unaccounted-for abstractions. This is at the heart of the lure of the abstract—this explains why artists keep returning to the elusive zone. Abstraction is not the contrary of representation, a recognition of which is the key to understanding the melancholy of Gerhard Richter's work, for example; rather, abstraction in art is the contrary of the abstract in the same way that representation is the contrary of the real.

Concrete structure in this case also lacks. It does not hold a functional role within the culture beyond its failure to be an abstraction. The concrete structure becomes a marker that signifies art and points to all other art as structures that contain excessive subjectivities. Abstraction in this case has little to do with minimalism or formalism. Yet it can easily become either of these things with just a slight tweak in any direction. The intention to create a minimal or reductive gesture, object, or environment requires a suppression of abstraction toward the deployment of materials that may or may not be in balance or sync with their objectness. This is not the same as the creation of an abstract artwork. The desire to develop a minimalist practice is a denial of the abstract and an attempt to concretize the concrete. Through this process there is the demonstration of a desire to ignore and go past the failure of abstraction. It is through minimalistic gestures that artists attempted to cut out abstraction's failure of transformation and invited us instead to focus on what we imagine is a material fact or set of facts about a material within a given context. The emergence of an identifiable minimalist practice more than forty years ago, while attempting to avoid the problem of abstraction, failed truly to trouble the problem

of abstraction. Minimalism highlighted evasion. The minimal created a series of half-facts, all of which continued to allude to the abstract of art. This explains the spiritualization of the minimal in the contemporary context, its interchangability and absorption into the aesthetic of the wellness center and the kitchen, and the association of truth to materials with truthy relationships to cosmic, mix-and-match spirituality.

The failure at the heart of the abstract is its enduring critical potential. The demonstration of the concrete brings down metaphors, allusions, and other tools that can be deployed for multiple ends to a set of knowable facts. Any attempt to represent through art will always deploy a degree of artifice—this is not a moral judgment, just a state of things. The failed abstract reproduces itself. It does not point to anything other than its own concrete form. Its concrete presence replaces the attempt to pin down the abstract and becomes a replacement object that only represents the potential of the abstract. This process of looking at replacement objects is one of the most provocative aspects of some art in the twentieth century. The presence of replacement objects as key markers within the trajectory of twentieth-century modernism is what provokes confused and sublime responses. It is not the forms themselves that have this essential quality. The search for ever more *true* abstraction merely created and continues to create more replacement objects that scatter across the globe as reminders of the failure of the concrete in relation to the abstract. This replacement function explains why the concrete in relation to the abstract is so vulnerable to being deployed for ends other than the progressive and neotranscendental. The earlier concretization of the abstraction of corporate identity via the creation of logos and smooth minimal spaces can be viewed in parallel to the failure of the abstract in the late-modern period—particularly in the United States.

Abstract

The endurance of abstraction is rooted in this desire to keep show-ing the impossibility and elusiveness of the abstract. At the same time, it reveals the processes of manipulation that take place within unaccountable realms of capital—the continual attempt to concretize abstract relation-ships and therefore render them into a parallel form that can be more easily exchanged. Where in the past the concrete was created from the abstract of the corporate, now these processes of concretization have moved into every realm of the *personal*. The abstract art produced alongside such a period is a necessity. It forms a sequence of test sites to verify and enable us to remain vigilant about the processes of concretization that take place around us in the service of capital. The transformation of relationships into objects via a mature sensitivity to a process of concretization is tested and tracked when the most vivid current artists deploy what appears to be abstract but is in fact a conscious deployment of evasive markers.

Allison Katz, *Daymark* (installation view at 1857), 2012.
Courtesy of 1857, Oslo, Norway.

Amelie von Wulffen, *Ohne Titel*, 2012.
Courtesy of Galerie Meyer Kainer, Vienna.

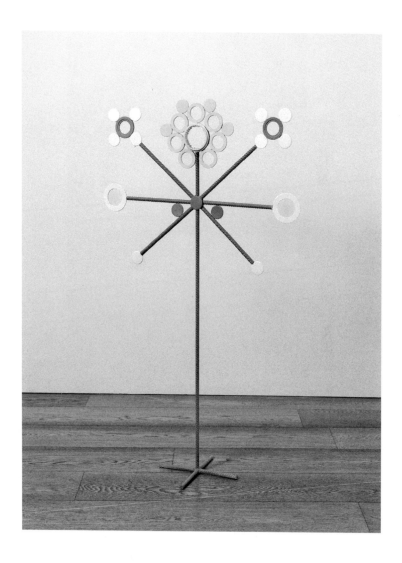

Andreas Slominski, *Flower*, 2011.
Courtesy of Sadie Coles HQ, London.

Astrid Klein, *Untitled (Lydia C)*, 2012.
Courtesy of Sprüth Magers.

Bernard Piffaretti, *Untitled*, 2012.
Courtesy of Cherry and Martin, Los Angeles.

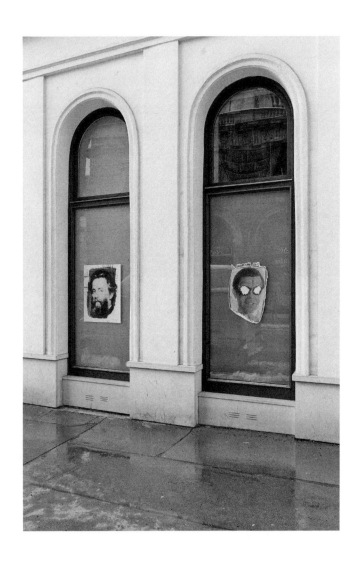

Bernhard Frue, *Gesichter*, 2013 (detail, installation view).
Courtesy of Galerie Mezzanin, Vienna.

Caleb Considine, *Patrick*, 2012.
Courtesy of Bureau Inc., New York.

Christopher Knowles, *Untitled*, 2012.
Courtesy of Gavin Brown's enterprise, New York.

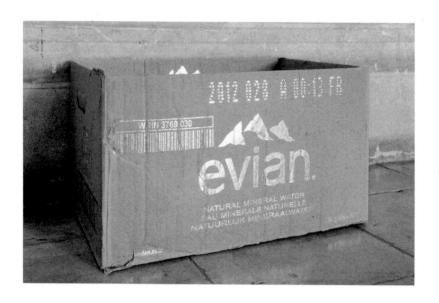

Danh Vo, *Grand Canyon*, 2012–13.

Courtesy of Marian Goodman Gallery, New York.

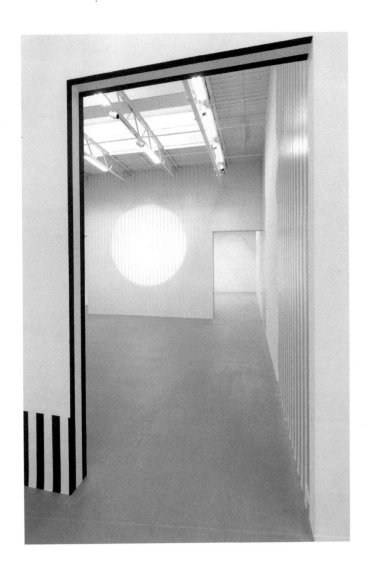

Daniel Buren, *Electricity Paper Vinyl . . . Works in Situ & Situated Works from 1968 to 2013 (DEDICATED TO MICHAEL ASHER)* (exhibition view), 2013. Courtesy of Bortolami Gallery, New York.

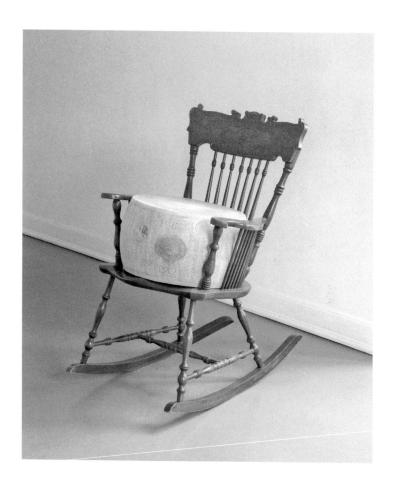

Darren Bader, *Antipodes: Parmigiano-Reggiano* (detail), 2013.
Courtesy of Galleria Franco Noero, Torino.

Doug Aitken, *MORE* (shattered pour), 2013.
Courtesy of 303 Gallery, New York, and Eva Presenhuber, Zurich.

Ed Atkins, Ribbons, 2014.
Courtesy of Isabella Bortolozzi, Berlin; and Cabinet Gallery, London.

Ei Arakawa and Nora Schultz, *Social Scarecrows Printing Fields*, 2013.
Courtesy of Reena Spaulings Fine Art, New York.

Emily Sundblad, *A Day at the Races 2 (The Aqueduct April 21, 2011)*, 2011.
Courtesy of Algus Greenspon, New York.

Frances Stark, *Clever Stupid Pirouette*, 2014.
Courtesy of Galerie Buchholz, Berlin/Cologne.

Giuseppe Gabellone, *Ruggine e Rosso Cocciniglia*, 2014.
Courtesy of greengrassi, London.

Günther Förg *Untitled*, 1991.

Courtesy of the Estate of Günther Förg, Neuchâtel.

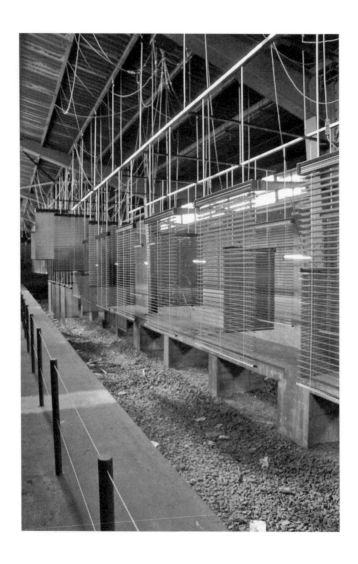

Haegue Yang, *Approaching Choreography Engineered in Never-Past Tense*, 2012
(installation view), documenta 13 2012.
Courtesy Galerie Chantal Crousel, Paris.

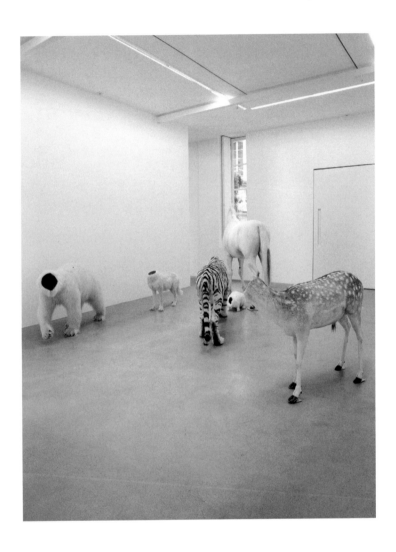

Huang Yong Ping *Bugarach*, 2012.
Courtesy of Kamel Mennour, Paris.

Isa Genzken, untitled, 2010.
Courtesy of David Zwirner, New York, and Galerie Daniel Buchholz, Cologne/Berlin.

Jason Dodge, installation view, 2012, Kunstverein Nurnberg.
Courtesy of Casey Kaplan, New York.

Josef Strau, *Redemption as Portrait and Photography*, 2012.
Courtesy of Josef Strau and House of Gaga, Mexico City.

Juetta Koether, *Berliner Schlüssel #13*, 2013.
Courtesy of Galerie Daniel Buchholz, Cologne/Berlin.

Kerstin Brätsch and Adele Röder, *Vorahnung* [*United Brothers and Sisters*]
(installation view), Kunsthalle Zürich, 2011.

Lara Favaretto, *Momentary Monument IV*, 2012 (installation view), documenta 13, 2012.
Courtesy of Galeria Franco Noero, Turin.

Leonor Antunes, *Villa, how to use* (installation view), 2011.
Courtesy of Isabella Bortolozzi Galerie, Berlin.

Lutz Bacher, Portikus Frankfurt (installation view), 2013.
Courtesy of Galerie Buchholz, Cologne/Berlin, and Green Naftali, New York.

Lutz Bacher, *The Sand Beneath Your Feet* (installation view), 2012, Alex Zachary, New York.
Courtesy of Galerie Buchholz, Cologne/Berlin, and Green Naftali, New York.

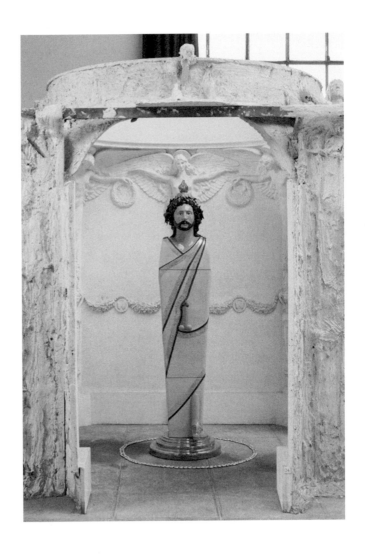

Luigi Ontani, *AnderSennoSongo* (installation view), 2013.
Courtesy of Lorcan O'Neill, Rome.

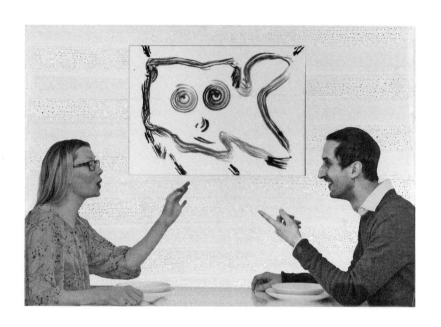

Will Benedict *Bonjour Tourist (Orange Kristina and Green Michi)*, 2012.
Courtesy of Galerie Meyer Kainer, Vienna.

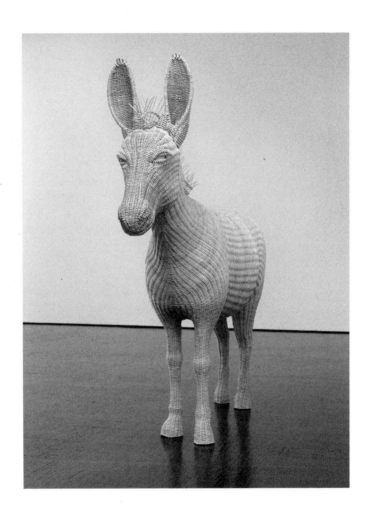

Mai-Thu Perret, *Balthazar*, 2012.
Courtesy of Simon Lee Gallery, London, and David Kordansky Gallery, Los Angeles.

Maria Loboda, *General Electric* (exhibition view, Andrew Kreps Gallery), 2013.
Courtesy of Galerie Barbara Weiss, Berlin.

Matias Faldbakken, exhibition view, Le Consortium, Dijon, 2013.
Courtesy of the artist and Standard, Oslo.

Michael Krebber, *Untitled*, 2011.
Courtesy of Real Fine Arts, New York; Green Naftali, New York; Maureen Paley, London.

Michaela Meise, *The Sick Book* (exhibition view), 2014.

Courtesy of dépendance, Brussels.

Nikolas Gambaroff, *Tools for Life*, 2012.
Courtesy of Overduin and Co., Los Angeles.

Oscar Tuazon, dépendance, 2013.

Courtesy the artist, dépendance, Brussels; and Eva Presenhuber, Zurich.

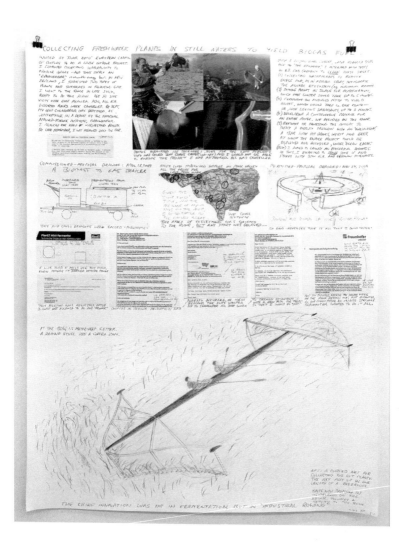

Peter Fend, *Uber die Grenze: May Not Be Seen or Read or Done*, 2012.
Courtesy of Essex Street, New York.

R. H. Quaytman, *Passing Through the Opposite of What Approaches*, chapter 25, 2013.
Courtesy of Gladstone Gallery, New York, and Miguel Abreu Gallery, New York.

Rachel Rose, *A Minute Ago* (video still), 2014.
Courtesy of Pilar Corrias, London.

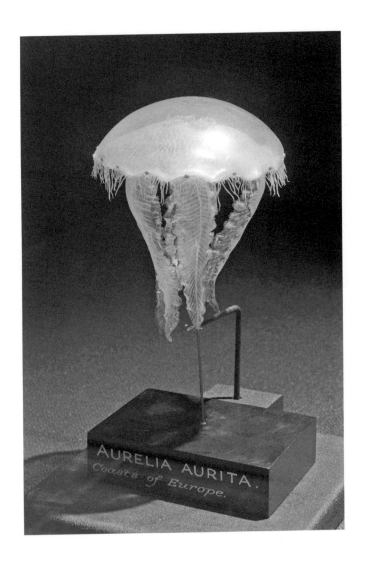

Rosemarie Trockel, *Rosemarie Trockel: A Cosmos* (installation view),
Serpentine Gallery, London, 2013.

Courtesy of Gladstone Gallery, New York, and Sprüth Magers, Berlin.

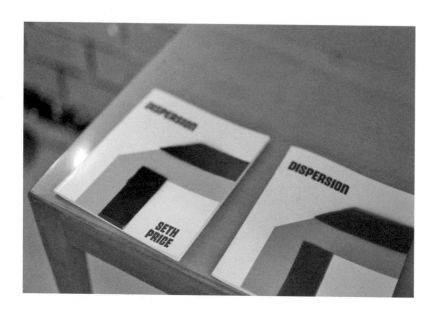

Seth Price, *Dispersion,* 2008 (installation view), Desaga, Cologne, 2010.
Courtesy of Petzel, New York.

Simon Dybbroe Møller, *O and No* (detail), 2011.
Courtesy of Fondazione Giuliani, Rome.

Tacita Dean, *Fatigues*, 2013 (installation view), documenta 13.
Courtesy Marian Goodman, New York.

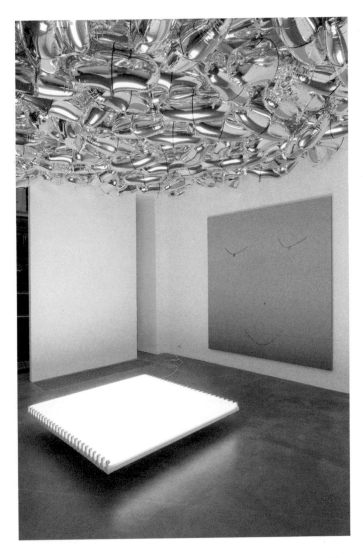

The Magic Bullet, 2013 (installation view), work by Jeremy Shaw, Rob Pruitt, General Idea, Berger & Berger.
Courtesy of Torri, Paris.

Thomas Bayrle, Monstranz, 2012 (installation view), documenta 13.
Courtesy Galerie Barbara Weiss, Berlin.

Tom Burr, *Deep Wood Drive* (exhibition view), 2012.
Courtesy of Bortolami Gallery, New York.

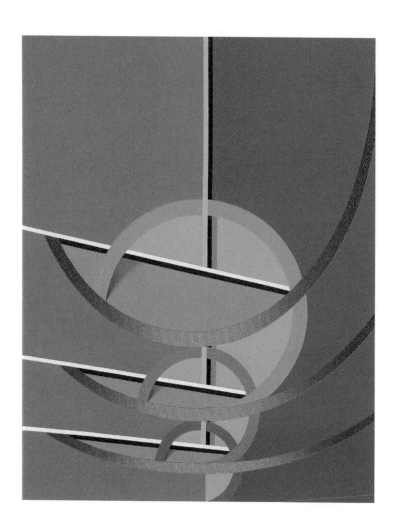

Tomma Abts, *Leeko*, 2009.
Courtesy of greengrassi, London.

Tony Conrad, *WiP*, 2013.
Courtesy of Green Naftali, New York.

1963: Herman Kahn and Projection

Around 1963 we encounter the rise of incremental production in the face of new political unions, the emergence of new identifications, new body consciousness derived from the clone and transplantation, the operation of the body in time rather than space, and the use of new technologies to describe the artist's presence and an increasing consciousness of production sites.

In 1963, the United Kingdom's entry into the European Economic Community was vetoed by French president Charles De Gaulle. An expansion and limitation of territory at the same time was therefore achieved. In a postwar Europe with its desire to create political unions in order to prevent further conflict, the participating nations began to be affected by a new hegemonic power operating inside and out. While there was a desire to expand the union of states, there was also a pressure to limit territory while asserting forms of interdependence. The European Union had grown from a bilateral agreement into an embryonic federal state. In 1963, it was the traditional left who most strongly opposed the protoneoliberal potential of the European Union as a trading framework, as it was still possible to view a federal Europe as a sequence of agreements in regard to

the breakdown of tariffs, borders, and protections rather than a politically unifying structure. De Gaulle's veto of Britain was a component of his skepticism about Anglo-Saxon power, and it created an articulated set of strains upon the idea of cultural presence via its insistence on territory as an enclosure of specific histories and practices.

Sanctions against Cuba were introduced in 1963: the creation of new enclosures with economic weapons, a return to the blockade or siege using pure capital to demonstrate power. While it has been enormously successful in creating a universal health and education system, Cuba failed to create a significant new development of applied Marxism in the face of the decay resulting from capitalist sanctions and a forced accommodation of Soviet support. Cuba also failed to generate the ideological energy to produce new texts, replacing this lack with an excess of writing and speeches. The use of economic weapons as a capitalist method began in 1963 and would be used repeatedly and enduringly from then on. When sanctions met resistance, those resistant were doomed to redescribe constantly their own resistance. In the United Nations and the U.S. government there was a concerted effort to continue postwar processes of decolonization and independence without conceding to state communism or any dangerous levels of resistance to the emerging hegemony. The United States was confused over how to deal with all this. The beginning of the contemporary distrust of the United States as a political and military power was rooted in its impossible-to-justify support of leaders of these postcolonial regimes. This erratic behavior was stoked by the European inability to depict the ongoing transfer of power and people or articulate differences. Things were out of sync. The notion of continued independence and the ongoing transfer of power required representation yet could not be represented within mainstream cultural practice beyond the nuances of abstraction and a yearning for universal languages.

In 1963, ongoing shifts in the theorizing of identity took a further step with the publication of Betty Friedan's *The Feminine Mystique*, which reached the suburbs of postwar consumer society.[1] These new struggles over identity demonstrated the way game theory and other strategies that were being deployed by the RAND Corporation, government advisors, and corporations only accounted for imagined constructions of society. Their attempts to account for everybody only resulted in neutralized reflections of themselves. The theorizing of identity, whether feminist or challenging heteronormativity, produced new subjectivities, and this created educational stresses. Earlier in the postwar period, education had been seen as potentially universal; by 1963, it was a locus for struggle. Assessment was deployed as a lure, an answer, and a way out of situations. But by 1963 it became clear that assessment was linked to institutionalized sexism, racism, and exclusion. Yet improvised education was part of a resistance to political repression. This coincided with an emerging sense that artists should be part of an educational process through the production of objects that required understanding: art as an extension of advanced reading. Battles over articulacy therefore became a form of resistance as much as direct resistance itself. The poetic political graffiti of 1968 began as a clear demonstration of articulacy as a form of resistance. Education as a locus of passive struggle and a theorizing of identity were both part of a reclassing of shared positions—a sense of solidarity across traditional boundaries toward new models of unity that echoed and transcended classic labor organizations: a buildup of groups with shared general desires. Coalitions and accommodations would self-educate.

A consideration of technology at this point produces an interesting set of excesses. Lamborghini began as an agricultural-machinery company that commenced the production of sports cars in 1963. This set into action the idea of the small-scale entrepreneur as an innovator who counters

the corporate by producing excessively unnecessary objects of desire. The surpluses of their labor resulted in apparently contradictory production. Lamborghini's knowledge and ability to produce short-run, specialized agricultural machinery and to adapt each machine for specific uses created permutations within the sphere of productivity replete with nuances and subtle reiterations. The idea of the "industrial handmade" was reified.

While the technology of eradication was bogging down in the mud of former colonies, South Vietnamese president Ngo Dinh Diem was assassinated in 1963. Advisors and conspiracy were at the heart of struggle over this colonial legacy. Conflict operated in sync with political strategy and in concert with excessive advice and commentary. This led to phantom wars and the rise of the insurgent who sits within the population. Images from Southeast Asia were repeatedly broadcast in a context where the instant replay had just been introduced on television, allowing the examination of action in detail. Experience was mediated by the ability to imagine oneself in detail as a result. It is from this point that children, as they played, started to imagine themselves in slow motion as they took part in their own actions—Sam Peckinpah meets the high points of a soccer game between Leicester City and Halifax Town on a wet Saturday afternoon. New forms of self-awareness accompanied the production of a goal, an action, a death, or a social meeting, and these could now be imagined in repeated slow motion. The idea of re-running an action as a self-consciousness was set into play. Re-running became a self-censoring act—adding more drama through the replay—catching microexpressions and microactions. Amplifying the moment of arrival, meeting, success, or death. Becoming someone else as one imagines and repeats oneself. This sense of self-consciousness via the playback meant that when video cameras came into the hands of artists they immediately accounted for themselves and recounted what they were doing.

Also introduced in 1963 was the word "clone"—one of a number of new names for posthuman states that had already been presaged by the popularity of science fiction in the postwar period. The word "clone" was part of a rise in terms that accounted for scientific developments that threatened subjective consciousness and therefore desires for free will and agency. The arrival of the clone produced an identification with the double and multiple self. The artist as a multiple self was responsive to this idea of artists being disinterested or excessive representations in reaction to a perception of the norm. The clone was what the corporation produced but was also something that universal education instilled. To be conscious of the clone or semihuman became part of an artistic self-consciousness. It became a state that could be used to parody, undermine, and accentuate stresses. The clone or automaton could evade education, for it was already preprogrammed. The clone could avoid behaviorist fantasies and the psychologizing of everyday life. The artist clone could repeat what it was preprogrammed to do and thereby create a culture of permutation.

Human-organ transplantation was reaching new levels of success. Along with the clone a new technology for death avoidance was set into action. Rejection became a paradigm leading to an awareness of allergies and autoimmunity. The struggle of the body to adapt to medical technology and developments fed into the consciousness and became part of representation. The body of the artist began to mimic that of the autoimmune body. The artist becomes one who fights his or her own presence and production. Clone, transplant, and rejection were the new lexicon of the artistic self, embracing the idea of rejection as a positive representation of the struggle to adapt to modern life. The artist's body itself became raw material—sometimes literally raw. The artist embraced new technologies for avoiding death and emphasized the posthuman aspect that would result.

The year 1963 set up a sequence of bounding ideas that point toward our time, creating a genealogy of artistic production that can help us understand the factors of contemporary art. Crucial here is the idea of the presented self—the sense that one is taking part in a mediated existence. This had already been theorized in the 1950s, but it became actualized within the context of new states of being.[2] With the emergence of targeted groups—pressure groups and semiautonomous groupings—a defined pushback began against dominant systems. The identification of groups was a technique used by the corporate and the resistant. All of this was connected to an examination of the self. The artist became a self-conscious presentation. The artist represented someone outside of the targeted group and became a paradigm of hypercategorization. Artists created semiautonomous groupings, improvised, chaotic, or politically focused against the dominant system.

Projection and the use of scenarios as tools became a key bounding idea during this period. The use of projection was integrally linked to predictive scenarios, including education, where ideas circulated around the notion that technology was accelerating and that technologies would be joining us soon that would allow people to connect more closely and integrate more smoothly. This sense of projection and the scenario functioned in relation to economic and social growth. These things would take place. There would be economic and social growth even in the face of evidence to the contrary. Any evidence to the contrary was a blip that must be overcome. Projection and scenarios were morally blind in the sense that they related to ecological consciousness as much as they were in the service of the industrial-military combine. They both relied upon projection and the scenario as tools, and, therefore, artists also reacted to such things. They began to play with time as a medium—either the slowing down of action, the replaying of action, the decoding of action, or the corruption of temporal codes. The artist

projected new spaces—other places with new time signatures—that were defined and described by the human body. The human body was used in direct engagement as a measuring device.

The year 1963 saw the ongoing rise of extragovernmental strategy engaged in a battle over transparency in the context of the knowledge that the government was working covertly. This was partly attributable to the maturing of agencies dating from the prewar and wartime period. This maturing of agencies led to a paranoid conception of strategy from within and without. The continuation of the permanent Cold War dance entered the private and improvised sphere. This knowledge of conspiracy affected all forms of creative work. Artists held out against overdrawn differences within an awareness of their own paranoia. The contemporary world had become a managed world, and management values were applied to everyday life. There was a sense of management as an expression of the complexity of modernity. An excessive parody of analysis existed in the proliferation of the "master of business administration" degree. It is no accident that at the same time artists began to interfere, take over, and question the management and administration of their own practice, whether that was by claiming the authority of the critic, founding alternative artist-run spaces, or developing the notion of art as a career. These acts were connected to a resistance to management values, but they were also a demonstration of the desire to take over self-management. A constant feature of the sit-in and the workers' occupation was the idea of managing oneself as a pushback against the rise of management: a questioning of set hierarchies and a disruption of speeds of communication.

Emerging countercultures pushed back against technology and management. While new technology was supposed to be the future, the computer at this point was only an arm of governments, corporations, universities, and research facilities. It was not until the mid-1970s that the Californiazation

of computing began: the idea that computers could be part of a libertarian, open network of communication. This Californiazation of computing proposed a seemingly utopian networking of individuals that would somehow free us all. Ironically, it was influenced by the pushback against technology in all its forms that began around 1963. We still see this apparent contradiction today in the commentary on the perceived stresses of contemporary life being both accelerated and eased by computing. For some artists it was better to push back against technology in order to prevent losses in the face of strongly promoted networking and excessively articulated pushes toward self-management; others embraced new technologies and attempted to hack their frameworks of control.

The workplace during this period became the site for conspiratorial meetings. The corporation was out of control, manipulating not just its employees but everyone else. Industrial espionage reached a peak. There was a final pushback by the state to lock down borders and exchange controls. Controls were erected within the state and the body. Phones were tapped by agencies and governments and intercepted by competitors. The artistic persona was viewed as one that might be ideally suited to resisting these processes even while members of the Art Workers Coalition were having their phones tapped by the FBI.

Yet the art context had already placed itself under surveillance and was somewhat compliant. The workplace became more and more a site for the expression of applied modernism. Late-modernist abstraction was a symbol of pseudoautonomy. The shift from idealized utopian pavilions toward the corporate pavilion had already taken place. Most applied architecture shrugged in relation to these art anxieties. Architecture seemed indifferent to the dilemma of the corporate versus the applied utopian and mined both. This indifference created new potentials and tensions for the artist and more damaged space within which to operate.

So how might it be possible to synthesize a genealogy that will allow an understanding of the key features that underscore contemporary art? An awareness of conspiracy, excessive management, and an inability to represent the postcolonial in light of the growth of independence movements combined with the difficulty of being able to absorb the implications of new medical technologies, all while being confronted by a rapid acceleration in the deployment of technology. Unsurprisingly, time emerged as a key component of contemporary art. Of course, some of this was affected by the role of music and cinema in the conception of space/time within theoretical approaches that were applied to art from elsewhere. Nevertheless, the forms and techniques of art, dance, music, and cinema began to come together as embryonic forms of contemporary art. There was a shift—a recasting and a scanning of space/time sensibilities across one area to another. Art became a film in real time, one where the setting of work, the displacement of form, and the presentation of the artist's film placed the viewer into an unsettled role. Formal abstraction at this point was diminished to a workplace backdrop to conspiracy—synthetic abstraction in relation to corporate architecture and new lifestyles functioning as an acritical support for abstract capital. Yet similar forms would eventually find a new role as a setting for temporal games. Additionally, art's backdrop function for conspiracy continued to expose ethical battles: art's fundamental lack of separation from new work styles and lifestyles revealed its simultaneous striving for autonomy. The claims for art moved out of sync with its effective deployment. It's not that art had ever reached a point of avoiding the contradictions between intentions and results. Rather, older conceptions of bourgeois taste in relation to art were broken down by advanced abstraction finding a home in zones that were connected to the yearning abstraction of the new and corporate lifestyles. This rapidly drove further new forms toward new desires for autonomy and separation.

And, in turn, art's new locations pushed forward the desire for ever more new locations.

It is important to emphasize the increase in strategy, negotiation, and compromise as embodied awarenesses. Today these are the key components that surround the art context. And they are most profoundly visible when the opposite is claimed. For example, when it is claimed that the art object does not require or desire any articulation or negotiation, this is the strategy, negotiation, and compromise of a contemporary art that claims its own autonomy. Contemporary art develops a sense of art in relation to its self and its own settings. Art has become something in search of appropriate settings all the time. This includes the battle over criticism. Who possesses the critical voice? Attempts to possess the critical voice were deeply shaken by the emergence of the curatorial. The curator became the artist's conspirator toward new forms of strategy and negotiation: the curators themselves came to terms with mapping and deployment. Curating as a developed, sophisticated, advanced role was one that admitted problems and accepted that there was a requirement for education. Curating took *care* without having to take *responsibility* for the work. Forms became supports or backdrops. They shifted in significance, becoming settings and degraded but useful mise-en-scène. We saw this in the unleashing of artists as a set of deployments. Artists are aware of art's degraded authority—that's how they start. Yet excessive claims still sit beside an acknowledgment of limited function. Excessive repetition functions alongside a sense that there might still be a singular idea or a singular object worth reiterating. Consistent contradiction has become the primary marker of the contemporary.

In an attempt to create a prophylactic against reiteration and consistent contradiction artistic work has increasingly developed from the creation of a condensed core of ideas. The artist is in possession of a critical

narrative—expressed or not—and carried along like a shell. The biographical emerged as a set of nuanced histories, where the artist started to possess his or her own presence and became best at manipulating it. The artist was given permission to possess accounts of his or her personal history in relation to the work, which was no longer a principal concern of the historian or critic. The exhibition became a scripted experience. With the emergence of the curatorial counternarrative, recuperation and reassessment of earlier modernisms started to appear alongside the presentation of revised biographical trajectories. This ran counter to the artist's own productive biography of the self. The curatorial counterbiography is rarely synchronized with the artist but operates usefully alongside. The curatorial goes beyond the traditional call and response or resistance of the critic. Art is not presented to the curator for reply then further responded to or resisted by the artist despite appearances. The curatorial counternarrative creates parallel histories focused upon the history of exhibitions more than the discrete art object. There is a difference between the curator's interest in exhibitions and the artist's interest in exhibitions. They operate in functional parallel, but the status of the deployed artwork is toward different ends.

The rise of film and video in art contexts created a resistant container for ideas in relation to the battle over accounts of the recent past. Cinema presents personas in pursuit of realization or resistance. Film is a fundamentally parallel activity. The appearance of video in art became an accelerant to this sense of film as a parallel activity. A shift took place from the documentation of action to documentation itself as the primary carrier of activated nonaction. The artistic use of documentary strategies became a subject in itself. The artist deployed film and video in forms that could not be accounted for in cinema. Artists saw film as carrying what art fails to possess. Film has audience and architecture. In lieu of trying to take over

those failed two sites—with their structures, games, identifications, publics, and personas—the immediacies of film were instead a challenge to the durational competition between the gallery and the museum.

There is one simple political construction that is normally overlooked at this point. Populism marked the artistic terrain. Populism confronted the emergent political threat of the artist as a figure through an excessive reaction to what was deployed as art. Populism in Europe was represented by social democratic or socialist politicians as much as by the right-wing organizations who instrumentalized funding bodies and private foundations. Such populism was in direct confrontation to the politically conscious threat of the artist as a figure. Artists had become superaware of education and behavior while at the same time becoming super-self-conscious in terms of what they produced. All sense of public and audience and history and projection had folded in on itself. Artists pulled related activities into place and undermined them, leaving populists floundering. Contemporary art overwrote and absorbed all nuanced cultural practices that previously made universalist claims—poetry, dance, literature. Art was intellectually destructive. This threat and takeover was stressed by the absorption of artistic ways of being into mainstream and dynamic postcorporate capitalist life. Starting in 1963, the artist started to be viewed as an amoral paradigm, demonstrating new ways of producing while not working and working while producing nothing. Contemporary art became an exemplary waste of time—pointing out the obvious while becoming an excessive cultural presence. It offered new models of permanence—permanent work, permanent education, permanent self-consciousness, and permanent narcissism.

The shattered personality of the artist found a strange set of allies. Late-modernist abstraction shifted from the corporate to the individual supercollector. The great corporations no longer bought art on a handshake,

but emerging services sponsored it: banking, financial analysis, and so on. These were the high-end structures that attempted to control financial abstraction while at the same time providing money management to the new individualistic supercollector. And the new supercollector needed a new set of locations. Shortly after 1963, something distinct from the modern art museum began to emerge: the development of the *contemporary* art museum, which was often formed by people who felt rejected from an establishment that had founded various modern museums with specific ethics, objectives, and desires. The museums of contemporary art were promiscuous, sponsored, and part of a series of processes connected to management strategy—negotiation, compromise, and risk taking, all intended to be more responsive to what was actually being made and finding kindred spirits in the artists who refused to acknowledge any traditional hierarchies and who were highly conscious of coding, semiotics, and the limits of expression. Artists were synchronizing with a constructed society toward a transitory statelessness, leaving behind a model of shimmering stability within permanent work, permanent insecurity, and the willful delusion of endurance via deployment of the nuanced mass that would become contemporary art.

NINE

The Complete Curator

Over the last twenty-five years, the complete curator has emerged as a new agent within cultural practice. The complete curator is a heightened individual or group demonstrating varied responses to an ethical demand that exceeds what is being produced by artists and posits new models in advance of art being made today. The complete curator expresses disappointment with current art and weariness with art's inability to produce new societies and new relationships. It does so alongside a revived critical community bolstered by the academy and the rise of contemporary art as an area of advanced study. The complete curator desires a world expressed and realized by art, artists, and themselves, a world that expels the present domination of capital via the machinations of neoliberalism. The use of the word "complete" here does not imply *finished* but rather *full* or *having all the necessary parts*. The complete curator exists as an expression of art's lack. The complete curator defines itself by expressing disappointment with art's weakness and by describing heightened ideals and potentials hampered by the deployment of fundamentally diminished and limited art. This takes place within frameworks that reach out into the social

and political sphere in order to describe art's failure to escape from the rapacious drive of capital's reach. The complete curator is fully aware that cultural workers are part of a precarious class terminally alienated from the parallel insecurity of zero-hour casual workers. The complete curator is not a problem; it is the epitome of a process that began in 1987 when the first curators graduated from the Magasin in Grenoble. The complete curator starts from a questioning of exhibitions and moves quickly on to challenging the notion of a constructed, capable society of resistance and stability. The complete curator is met by the incomplete artist, who both resists and aids the curator in the latter's attempt to load expectations upon art, artworks, and art contexts—expectations that art can provide new worlds and demonstrate in articulate form the failure of the varied constructions of society that surround us today.

Three bounding structures appear to have dominated the growth, interpretation, and flow of art and led to this context of extended expectations on the part of the complete curator. Each of them applied pressures that have affected and moderated yet perversely enabled the expansion of contemporary art alongside a continued fragmentation of activated critical processes. The first of these dominant contextual structures is simply termed the art market. The contemporary art market is an apparently straightforward, barely regulated process of exchange that appears to be firewalled away from its more self-consciously critical others—the complete curator and its extended demands. The second is the general area of concern known as the curatorial, the complete curator's area of focus. If the curatorial has a bounding model at all, the curatorial increasingly derives its structural validation from the academy, the reimagined institution, and varied self-organized, self-conscious structures. The third is the positing of art as a paradigm of potential—a space of human action and interaction that could and should propose models that function outside of the capitalization of

every moment and every exchange. Where it cannot achieve this, the ideal is to produce work that at least exposes new potential models by default and in doing so avoids all contact with established forms of commercial art exchange. These three contextual models provide varying degrees of self-awareness within a regime of continued submission to the phantom of art's potential. It would appear, therefore, that we face a simple dichotomy in terms of how art should be developed, interpreted, and exchanged—either give in to a market model, where art flows through a commercial funnel into the hands of a small group of people while being temporarily shown off in the process to larger groups of people, or engage thoroughly with the complete curator and its attendant processes of fragmented self-consciousness and projected desires for the potential of art as a vehicle from which both to recognize and reject the current deployment of people, objects, and forms of exchange throughout societies and without limit.

In 1992, the Royal College of Art in London had begun offering an MA course, "Curating Contemporary Art." At that point, the idea of an advanced degree in curatorial practice did not suggest any guarantee of development toward the complete curator, new forms of curatorial consciousness, or even success. Subsequently, it has become clear that, by focusing on the struggle to deal with research and various apparently contradictory modes of activity and action within exhibitions, broader claims have been made about the potential of revised curatorial structures. Most importantly, the Royal College, along with the proliferation of similar courses since the early 1990s, has functioned understandably to structure critique in the face of the curatorial rather than art. It could be assumed that the proliferation of curatorial thinking would have been accompanied by new critical models that offered revised ways to address the problem of contemporary art. In some sense, this has been the case, yet it has mainly produced processes of criticality that have tended to overlook one key aspect, namely,

a critique of the ethically Western Judeo-Christian language at the heart of the complete curator.

Some observers have suggested that this has to do with the sometimes tortured language deployed by the complete curator in their places of display and interpretation, including the writing of artists. But loose language is not the root of a lack here. It is merely a symptom of something more deeply embedded in the communication and approval structures at the heart of a developed curatorial sphere. The complete curator has moved beyond the disappointment and partial quality of most contemporary art and has engaged a desire system that now points forward toward its own yearning for ethical social change. The complete curator has no need to build new critical models restricted to art as object or structural form, for it gains momentum from art's lack and an increasingly precise description of society's needs. It is not that the complete curator is incapable of deconstructing art's often wry and self-abasing engagements; rather, such an exercise has become a pointless task in the face of a new conversation with the academy and its own self-conscious institutions.

If the complete curator increasingly finds validating models in the academy and revised institutions, it has reduced its speculative role and conceded reaching forward to other structures. The discursive has become formalized within a frame that engulfs and diminishes critique simultaneously. Whole territories have now been abandoned in favor of reiteration and recuperation. Serious work takes place to reconfigure the distant past and leave the recent past and near future to artists and their degraded speculative structures. The structural premise of the exhibition has become a series of conceits that floats free of what is being produced. It is hard to find a curatorial strategy that could reflect the evasive techniques of artists in the face of a renewed dialectic between rocks and slate. The exhibition as a form has shifted from being a neglected aspect to the central and

functional focus of the complete curator. The artwork, in sullen response, has become resistant to the exhibition or only significant within the exhibition as form. The exhibition is no longer restricted to a moment or set period. It exceeds all temporal restraints and extends beyond any singular deployment of work. A singular deployment only has meaning in the context of the exhibition. The potential of discourse and filtration has given way to illustrations of accretion. The discursive cannot be accurately reproduced within a regime of didactics. Within this frame, research becomes any reading and could include any work. Any reading and any work gridded by didactics does not reproduce more than the content with which it started combined with the excessive framing that results. Research as an act of semiautonomy cannot be critically accessed within the regime of the complete curator. The process of research is a type of work that remains *just alongside* and is only sustained by the artwork's supporting role or perceived relegation to the market.

Alongside these developments, the art fair has remained a place of exhibitions arranged by gallerists that exists in sympathy with some curatorial consciousness but only within a retarded set of references that attempts to empty out all significance from the dominance of the exhibition as form. The essential relationality of the art fair actually diminishes any autonomous potential of the work—not because of processes of valuation and exchange but because of its echo of the exhibition as it existed prior to the advent of the complete curator. The navigation of the art fair only makes sense in relation to the exhibition as a historical experience. The art-school cubicle is perfect training for the future art-fair booth—lacking both exhibition and curatorial consciousness. The two are analogous architectures that are both phantoms of a precuratorial gallery. The contemporary mega-artist's compound of various production stages and workshops is the museum space of the precuratorial. The products of such luxurious

sites of limited production are no longer shipped out to become part of a megawork authored under the comforting regulations of the curatorial; rather, neither the work nor the interpretation of work can compete with the contextual drive of the exhibition as a form reified by the complete curator. Discursivity is excessively verifiable and forms a partnership with research as domains that appear to resist the reach of capital or at least keep precisely priced exchange moments at a distance. Discursivity and research ex nihilo are the strategies of the complete curator. They feed into each other and provide a push and pull in and out of precisely determined roles toward a continual identity in motion. While incapable of offering a complete break, this creates an image sequence of roles in motion that dazzles the insatiable desire of art structures that seek to pin down and possess and exchange the *products* of the complete curator.

The complete curator no longer locates itself in a tense standoff with specific institutional structures. The curatorial and institutional have meshed, melded, and reformed. The arrangement of structures has become the deployment of exhibitions. The institutional lays down a history of exhibitions and not a history of art or artists. At the same time, the complete curator focuses upon a history of yearning exhibitions and structures and no longer a history of artists and specific structures. The notion of a work in advance of any other work has become subsumed within the strategic demonstration of the exhibition as a form. The projection of potential through the discursive or the work of the artist filtered by the curatorial has been replaced by a verifiable sequence of steps that furthers the history of exhibitions over and above the potential of any given development. Within this terrain, the developed artist offers self-curation as a demonstration of fidelity toward the deployed exhibitionistic aspect of the complete curator.

The arrangement of ideas in space is nevertheless still mediated. Object combinations are no longer sufficient to function in relation to one another

by troubling the complete curator, who in turn does not agitate the limited sufficiency of the object, action, or intent. In this arrangement, the critical posture is permitted to float free from what is arranged and from the arranger of those things. A permanent exchange of absences has developed. An absent logic meets an absence of regard. Each deployed work is offset by an increasing sequence of contextually interpretive structures. The primacy of "art" in this constant flow of control between varied points is only visible when it resists the codes of the complete curator. The diminished status of art operates in direct correlation to its utility for the curatorial and its potential as a straightforward commodity signifier— an irresolvable doubling.

Research is both the base of certain artistic practices and the base of some of the methodologies deployed by the complete curator. However, research cannot be independently verified. Unless enacted within the frame of the exhibition, research is a term that may suggest lengthy engagement while the actual intensity of "finding out" is impossible to gauge. The gathering of material without judgment may be research; so could the detailed investigation of one minor object. Research carries a scientistic authority. Research implies an evacuation from zones of commodified exchange and directs us toward the apparent authority of the institutional library or laboratory. Alone it cannot build better systems or structures. Yet it can point out how far away they still appear to be.

Maybe It Would Be Better If We Worked in Groups of Three?

A discursive model of praxis has developed within the critical art context over the last twenty years. It is the offspring of critical theory and improvised, self-organized structures. It is the basis of art that involves the dissemination of information. It plays with social models and presents speculative constructs both within and beyond traditional gallery spaces. It is indebted to conceptual art's reframing of relationships, and it requires decentered and revised histories in order to evolve.

If we want to understand tendencies in art, we have to look at the structures that underscore the sharing of ideas. This is especially true when we consider discursive processes to be the base of self-conscious art practice. It is necessary to find a way to describe, map, and analogize the processes that have actually been taking place under the surface of recent models of curating and artistic practice. I'm trying for a moment to get away from anecdotal, local, and geographical relationships to artistic activity and away from "special event" consciousness. At the same time, I want to look at echoes in the culture that might provide a clue to parallel productive techniques.

The discursive is the key strategy employed by the most dynamic contemporary artists, whether they are providing a contribution to a larger model of exchange or using discursive strategies as a structural tool within their own work. I am trying to test the validity of this discursive framework in light of what has developed in the culture since the fall of the Berlin Wall. There are some returns and absences that may affect our ability to continue as before. We also need to examine the notion of the discursive as a model of production in its own right, alongside the production of objects for consideration or exchange. The discursive is what produces the work, and, in the form of critical and impromptu exchanges, it is also the desired result.

The use of the word "discursive" includes the following considerations. First, a technical definition: the movement between subjects without or beyond order. Second: a set of discussions marked by their adherence to one or more notions of analytical reason. At no point does my use of the word really imply coherence with notions of discourse-based deliberative democracy as posited by Jürgen Habermas and others,[1] yet within the cultural terrain it does have some connection to the idea of melding public deliberation while retaining the notion of individual practice within the "group."

The discursive is a practice that offers the opportunity to be a relatively unexamined free agent within a collective project. While the discursive appears to be an open generator of positions, it actually functions best when it allows one to *hide within the collective*. It allows the artist to develop a set of arguments and individual positions without having to conform to an established model of artistic or educational quality. Incomplete projects and partial contributions are central to an effectively progressive, critical environment, but in the discursive they are not expressed; rather, they are perpetually reformed. The discursive needs to retain this sense of reclaimed

speculation in relation to *lived* future models if it is to retain its semiautonomy in relation to instrumentalizing or divisive, chaotic, and insincere market rationalizations.

The discursive framework differentiates certain collective models, not the other way around. It is a mode of generating ideas and placing structures into the culture that emerges from collaborative, collective, or negotiated positions rather than as varied forms of *pure* expression or supersubjectivity. However, the discursive also provides a space where all these approaches can be included. The rise of content-heavy discussions—seminars, symposia, and discussion programs—alongside every serious art project over the last twenty years is very significant here. This phenomenon has given us a lot of time to excuse ourselves, to qualify ourselves, and to provide an excess of specific positions that are not necessarily in sync with what is presented in the spaces for art. These discussions are functional parallels that project in many directions. They are free zones of real production. They have also become an essential component of both didactic and contingent projects. Yet the discursive as a form of art practice in its own right is not reliant on these official parallel events. It both goes beyond and absorbs such moments, making them both material and structure, operating openly in opposition to official programming.

The discursive leads to the proliferation of the short text and statement, which both cover up and announce. The site of production today often exists within the text alone. The text is the key event, the key moment, the idea carrier as well as the collective project itself. The critical text is also the voice of the curatorial context. The site of the critical text is now often produced by the person who is an implicated multiple personality within the cultural field. The anxiety of contemporary curating is not the cliché of the idea of the curator as mega-artist or the curator as neurotic traveler. The anxiety is that the critical voice has been merged with that of the curatorial.

A misunderstanding has emerged here in the reaction to relational aesthetics, with the implication that this curatorial voice directs the critical flow. But this analysis of relational aesthetics got the moment of engagement the wrong way around—critical self-consciousness was activated before the predictive text backtracked and set the scene.

This is a common phenomenon of the discursive: the postdescription of critical awareness, often in a straightforward form. The idea of a directed series of actions comes after the negotiated quality of the discursive. Moments of entry into the critical framework are muddled and inverted as a result of the struggle over the text having been transferred (as an anxiety) from the artist to the curator. Yet we still make assumptions about the root of critical potential emerging from the moment at which a flow is identified, rather than from the flow itself.

Recently we have seen the rise of a new group of people who have studied art history but have resisted or found no place within the standard systems of curating. This new *nongroup* has not been completely identified, manipulated, or instrumentalized by the dominant culture—yet. They appear to be deeply embedded within hierarchical academic structures but also do not deal with the merging of voices that constitutes a symbiotic alliance between the discursive and the curatorial. These are people who studied art history but don't all want to be curators. They don't all want to be traditional critics, either. They have started developing a series of relationships, discussions, and texts that have created a new series of links between the potential of the discursive framework and much more traditional forms of academic work. Most of it is focused on trying to understand where the critical flow exists within the culture.

All of this is based on the understanding that statements are also events. Statements depend on the conditions from which they emerge and start to exist within a field of discourse. Statements as events are important within

the discursive—they provide a *location* from which to propose a physical potential beyond the immediate art context. Putting a statement into play will create an event "at some point" or a series of events projected into the near future to recuperate the recent past.

By the time a generation born in the early 1960s had become activated recipients of a postwar social dynamic, they were simultaneously told that the physical manifestations of it—in varied forms of applied modernism—were failing. They were told that they were within something that might appear to be succeeding and functioning in theory but were also told that certain markers of progressive modern existence were not functional, wouldn't work, and were wanted by no one. Reconfiguring the recent past accounts for this tension. It is a crucial component of a desire to be involved in a discursive frame that is often marked by architectural and structural legacies of the recent past—from public-housing projects to communal experiments—which were viewed as failures by both right and left.

At the heart of the discursive is a reexamination of *the day before* as a model for understanding how to behave, activate, and present. It tries to get to the point *just before* the only option was to play the tuba to the workers. In the past, I have used this quite frequently as a device: the day before the brass band became the only option, the day before the mob became the workers, the day before the factory closed, the day before *Hotel California* was released—the idea of a French bar in the middle of nowhere, with nothing to listen to and everyone waiting for the arrival of the *soft* future.

The role of the discursive is to not look back too far. However, this creates peculiar problems. Reoccupation, recuperation, and aimless renovation are the daily activities of a unified Europe and the function of the discursive framework as well—creating engagement and providing

activity. However, the intellectual and ideological implications are rather more problematic.

We are currently in a situation in which suspension and repression are the dominant models. There is anxiety about who controls the reshaping of the stories of the recent past. The discursive framework has been predicated upon the rejection of the idea of a dominant authorial voice. Clear-cut, authored content is considered to be politically, socially, and ideologically suspicious. However, there is still the feeling that stories get told, that the past is being reconfigured, and that the near future gets shaped. There is a constant anxiety within the discursive frame about who is doing this, who is marking time. The discursive is the only structure that allows you to project a problem just out of reach and to work with that permanent displacement. Every other mode merely reflects a problem, generates a problem, denies a problem, and so on. The discursive framework projects a problem just out of reach, and this is why it can also confront a socioeconomic system that bases its growth upon "projections." In the discursive art process, we are constantly projecting. We are projecting that something will lead to something else "at some point." True work, true activity, true significance will happen in a constant, perpetual displacement.

This permanent displacement provides a location for refusal and collective ennui. The projection of the critical moment is the political potential of the discursive. It is not a location for action but instead provides an infinite suspension of critical moments—the opposite of performance. This is its *just-around-the-corner-ness*—a permanent interplay of microcritical expressions within the context of a *setting*. Projects are realized that expose a power relationship with the culture. They achieve this through an adherence to parasitical techniques: destroying relations of production through a constant layering of profoundly differing and contradictory

aims. Somehow it might be possible to bring together small groupings and create temporary, suspended, semiautonomous frameworks. It is possible that we have seen a rise in the idea of parasitical relationships to the point where they have reached a fluid state of acceptance. We may have reached a moment of constant reoccupation, recuperation, and aimless renovation. Maybe the discursive makes it possible to be a parasite without a host—feeding off copies of itself, speaking to itself, regenerating among its own kind.

The discursive demonstrates a clear desire to produce situations that are open and exchange oriented in tension with the forces that encourage self-redundancy. It is an activation of countermethods. We've had flexibility, and now we are redundant, yet we refuse to stop working. The discursive cultural framework is the only way to challenge the forces that encourage self-redundancy, as it internalizes and expresses consciousness of the most complex and imploded forms of post-Operaistic models of developed capitalism—the notion that capitalism mutates in the face of a reluctant workforce rather than because of some naturalistic quality or its own drive.[2] Teamworked, flexibilized environments are also a way to induce people to create predictive models that are resistant to true projections of future circumstances. Everything is permanently conditional and contingent and needs to be predicted in speculative form.

This phenomenon is combined with the increased sophistication of the dominant culture in finding ways to use and absorb earlier critical structures in order to create a degree of information control. The discursive adopts and co-opts this structural approach, too, but to different ends. It is the only way to offer a functional parallel to the dominant culture. In a discursive frame, there is always a critical double that has a degree of parallelism with the machinations of globalized capital. The discursive always functions in parallel or just across from the idea of something that

The Return of the Border

The discursive becomes easily absorbed because it has borderless qualities. It has become a crucial component of the contemporary art *biennale*, and an idea that the discursive encourages an internationalized border-free methodology is crucial to its potential failings and collapses.

The occupation of time rather than space creates new problems of edge. We operate in a tension with the federated structure of recent European political consolidation. The edge is a modernist analogue. European neurosis is based on anxiety about the edge in connection to the victory of the federated over the republican. The federated as an idea is something that tends to be ignored in relation to art, but the discursive framework often functions like a federated series of organizations—once it goes beyond the collective, or beyond the communal, or beyond the suspended, it essentially becomes a series of federations. It's not a republican model, and it's not truly a supersubjective model; it is a federation of relationships. It's not even truly collaborative, and this becomes a key question when the idea of the edge of the federation becomes a political marker within the European Union, when you realize that the operatives of the discursive may

be echoing the federated tendencies of European politics. How can you sustain a discursive framework without consciously acknowledging it as an echo of the federated?

The postwar is over and is now a definable historical period. You can identify the postwar as a time when the social democratic project of Western Europe and other places that shared its cultural and political pressures could be rethought. The postwar had its various moments of trauma, doubt, and complication, such as the 1948 election in Italy, when the communists were expected to win by a landslide and the CIA initiated its first real operation to undermine an election in Europe by paying the Christian Democrats to make sure it didn't happen. Alongside these suppressed histories, we can talk about the general liberalized, democratic project, which created the context within which artists like myself developed and which led up to a *unified*, federated Europe with a proliferation of new states within a liberal consensus.

The discursive framework is challenged by shifts in postwar geography, which involve the return of the edge or border. Suddenly, the idea of the edge of Europe has become an urgent populist question in a new way. This anxiety has been compounded by the atomization and disappearance of the postwar American military presence within Europe and its sudden coalescence as a singular army at permanent war and reunited with symbols of power and piety. The reappearance of the American army in Iraq took a form that was only possible after it had abandoned its role within Europe as guardian.

The end of the postwar allowed both the discursive to coalesce freely *and* the U.S. Army to be deployed finally in a proudly aggressive form. Postwar consensus with regard to models of behavior and models of production ends with both the completion of European federation and when the United States and its allies declare permanent and endless war on the

illogical and uncontrollable *other*. When the postwar is over, we face new anxieties in the relationship of the state toward art, and vice versa—the legacy and influence of U.S. models of modernism, the sustaining potential of modes of refusal based on subcultures, and new questions about how to find images and identifications within other cultures.

1974: Volvo and the Mise-en-Scène

The year 1974 brings endless work in the context of the emergence of technologies that use a simple interface; contraction, limitation, and exit as negotiated by subcultural assertion; the absorption of other disciplines into art; the consolidation of contemporary art as a describable zone; the arrival of the curator; and the development of super-self-awareness of the artistic condition as a subject.

In 1974, Hiroo Onoda—a Japanese soldier who had been in hiding since 1945—finally surrendered. An isolated individual ignoring technology, development, and compromise, Onoda had refused to accept the emperor's surrender at the end of World War II. In postwar Europe, implicated figures had smoothly moved into postwar roles, in an attempt by the victorious powers to keep bureaucratic structures functioning in the now-occupied Europe and prevent a repeat of the economic and social collapse of the 1920s. This smooth move in Europe was questioned and resisted with force and, more often, with public condemnation and exposure.

While Onoda was refusing technology, the passage of time, development, and compromise, a soft coup d'état had taken place in the midst of

a collapse of Portuguese colonial authority in Africa, which had become overwhelmed by the proxy war games of East and West. Onoda's refusal to believe the war was over was not entirely incorrect—his resistance mirrored a standoff that had become global and permanent. The Carnation Revolution was a soft revolution from the inside out. Long-haired soldiers appropriately used Zeca Afonso's 1972 sentimental Portuguese country ballad "Grândola, Vila Morena" as a signal to action. It was time to give up and go home.

The introduction in 1974 of the first barcodes into a supermarket was a step toward self-administered consumption that would eventually lead to being able to check yourself out. Barcodes also enabled the distribution and monitoring of highly differentiated products—a way to track nuances. This led to the development of the consumer as a precise data flow. Barcodes were not only used to organize consumption; they were deployed to organize production. Barcodes had initially been developed to automate the organization of freight rail cars—a way to sort the movement of raw and finished materials. An advantage was that the barcode's internal language allowed direct machine–machine communication, bypassing human accounting.

Parallel to the barcode was the introduction and rapid adoption of the pocket calculator, a device functioning as a personal interface that was simple, complex, and idiotic at the same time: whether summing 2+2, displaying the word HELLO when entering 07734 and holding it upside down, or solving hyperbolic inverse sines (arcsines) of a value or expression. This produced a shift away from a conception of arithmetic as being a mental space verified by approximation and prepared us for interaction with personal computers. The emergence of instant calculation prompted a desire for more interfaces. The potential of a personal interface that offered instant gratification operated as a lure and accelerant. This created a vision

of new computer forms and their potential interfaces: an introduction to a straightforward engagement with complexity. You did not need to know how the calculator worked. The introduction of the microelectronic address book quickly followed the calculator as the next step toward personal computing. The emergence of the calculator alongside the digital watch and the electronic address book was the first atomization of technology, creating further bursts toward a distribution of interfaces. While the obsolescence of everyday arithmetic produced an educational anxiety, it also led to the immediate death of the slide rule as a technology, followed rapidly by further deaths of analogue devices.

A legislation-driven limitation of resources appeared with the crisis over the oil supply. This was particularly profound in the United States. The introduction of a fifty-five-mile-per-hour speed limit combined with the fear of extended slow suicide that had emerged through the increased focus on smoking, overeating, and health in general. An increasingly phantom free will was combined with a tradition of puritanism and contradictory economic rationalizations. The city was seen as a body that needed to slow down and that required triage. There was a reduction and concurrent assertion of American freedom in relation to the modern world in these attempts to control speed and health. Anxiety was expressed economically, forcing people to take control of their own bodies as economic entities in context. A dynamic contradiction was set into play between the body and the collective in terms of how to behave. A crisis of impingement with negative assertion became increasingly dominant.

Government imposition of a limited industrial working week in Britain in 1974 confused the traditional industrial battle over time. What was quickly named the Three-Day Week was imposed upon the industrial workforce by the government as a way to limit production in light of the politically generated energy crisis and production battles between the government and

the unions. The removal of control over time from industrial workers contributed to a profound undermining of organized labor over the subsequent fifteen years. A last-ditch battle began in advance of the introduction of the permanent part-time, displaced, and outsourced labor. All of this was further confused by the accelerating use and abuse of former European colonial subjects by bringing them to their various "mother countries" and deploying them as a marginalized workforce—just in advance of long-term redundancy.

While the workers fought over time and headed toward permanent temporary status, 1974 also saw the birth of the twenty-four-hour news cycle, which created permanent connection, boredom, banality, and anxiety regardless of the events covered. The twenty-four-hour news cycle had to create breaking stories in order to feed itself. Twenty-four-hour news created anticipation toward the imminent event. At some point, there will be a new shared crisis, and, as a result, the anticipation of crisis accelerated. Anticipation became overwhelming yet numbing in its repetition, producing alienation from profound emotion and experience. Constant news provoked fight-or-flight instincts and boredom while giving the newly redundant workers something to watch.

The Volvo 240 was introduced in 1974, marketing safety and edging toward a postconsumerist symbol of eco-choice. Notwithstanding the former attractions of cars—style, performance, and newness—the postconsumer started to make choices that were part of the contradictions of ecoconsciousness. The idea of the long lasting and reliable was viewed as something that might be able to counteract an excessive consumption of fossil fuels or at least symbolize that desire via the possession of a boxy symbol of Swedish good taste and Lutheran responsibility. Each person leaves behind a potentially devastating trace, but now the individual could attempt to be responsible for things they could not control.

Despite attempts to the contrary, Hiroo Onoda could not control the war by refusing to surrender. Despite control of the army, the Portuguese government could not prevent its own soldiers from engaging in their soft revolution. The barcode led toward self-consumption—the consumer had become a dividual. The pocket calculator pointed toward the interface—a simple personal interface with technology that now exceeded the speed of the human brain. The slide rule had revealed contextual answers. It had demonstrated potentials on either side of a result. The calculator, however, offered a single answer that might as well be trusted. The awareness and legislated limitation of resources led toward postconsumer choices that were concerned about the contingencies of an emerging ecological consciousness. A battle over time was being won by government and corporate power. The twenty-four-hour news cycle would be consumed by the very people who were to become increasingly redundant and self-managing—yet full of information. Permanent work and permanent education were the only answers to this breakdown of time. Time became the key: the battle over time replaced the battle over the body.

There are a number of crucial bounding ideas that can be said to have emerged in 1974 and that point forward to a set of concepts that might help us understand the position of the contemporary artist and what he or she produces. The final stand of the worker in the battle over the possession of time coincided with the rise of cognitive labor in the framework of technological acceleration. The introduction of robot control in complex industrial production happened by 1978 with the Fiat Strada in Italy. This level of sophisticated automation required a new form of cognitive labor capable of programming both the machines and the context of redundancy to come.

The emergence of the soft, velvet, and flower revolutions from the 1970s to the 1990s emerged in opposition to the waning, parodic, deluded, and

self-policing travesties exhibited by the standoff between NATO and the Eastern Bloc. These revolutions were guided by identity politics and the resistant potential of popular culture's informal and apparently more human means of communication. Identity consciousness was deployed as a way to challenge authority. Everyone could become a dissident. Common ground could be found through individual readings of popular culture, and resistance could be created through indirect posturing. A set of resistant positions was accentuated by nonconformist appearances and recognitions that produced a flowering of desire. Such identifications were not immune from capitalization. By 1974, youth markets had consolidated. First-generation youth markets had started to feed off themselves. We began to see the emergence of pseudosports for the annihilation of time—and an expression of subjective testing. Skateboarding, riding tiny bikes, learning tricks: all to demonstrate the mastery of the body over a specialized commodified pursuit. There was a revolt against the repetitive techniques of earlier youth movements. Former tribal youth battles became cross-generational, confused, and compressed, producing a breakdown of unity and confrontation. The fragmentation of experience was emphasized in the emergence of the mixtape: the creation of infinite contexts for personal narrative. This was the origin of the curation of nostalgia and of the every moment.

Alongside such humanist resistance, the deployment of technology accelerated. Every year, future tools arrived but became less and less remarkable. In the early 1970s there were still television programs about the technology of the near future. But as these various tools and technologies actually appeared—personal computers, mobile phones, and television sets housed in crappy plastic casings—the incremental nature of their arrival and the feeling that these were less-than-remarkable surplus tools created a diminished relationship to the notion of the future, a capitalized, contingent, provisional vision. The future was no longer a place where objects

and devices could transform society through their liberatory potential. It became clear very quickly, as predicted, that these objects would become traps. They did not even rise to the level of a poorly articulated science-fiction dystopia; they were mere Radio Shack throwaway disappointments that would require more effort to use than they would offset—until the next development was released to great anticipation. As technologies were refined, a crisis of human interaction and knowledge production would take place. While it is true that these devices would become fetish objects, simultaneously they would control time and become a key component of self-management.

The introduction of future tools operated in tandem with the arrival of a permanent neoliberal crisis and the oppressive cycle of neoliberal logic. The capitulation of the left seemed on the horizon. There would now be permanent belt tightening, and former anxieties about asset stripping—the taking over and shutting down of companies while making people redundant—moved from industry toward abstract capital. Abstract capital became the new site of asset stripping. Abstraction eviscerating abstraction. Asset stripping operated in advance of reduced control. Asset stripping had already rendered control and limitation toothless. Business had already committed suicide via the complete destruction of its established structures and relationships. Reduced controls over financial exchange, banking rules, and movement of capital in general now did not precede but followed hard behind the total destruction of these established structures and relationships.

Lack of control is central here. Lack of control was not limited to finance; it was embedded in interface design. Controls via various interfaces were simplified. There were fewer requirements to read a manual. There was more focus on the idea that controls themselves would be self-evident and therefore fade. There was an acceleration of self-management

in the face of globalization. This coincided with an increase in surveillance and a maturing of oppression. Control was atomized and rendered infinite. The interface bypassed complexity. Bypassing became something to be achieved—the bypassing of controls, bypassing congestion, speeding things up, and rendering the interface or experience smooth to the point where it became impossible to distinguish work, labor, and life.

The consolidation of corporations followed the breakdown of nationalized industries. After the Second World War countries all over Europe had drawn together disparate and disorganized companies into large nationalized operations. When these concerns were privatized in the United Kingdom during the 1980s, they were often put into the hands of the recently retired ministers who had privatized them. This pattern was repeated across the developed world. There was a standard capitalist shift toward consolidation and "efficiency," but now in a globalized frame. Such processes were made easier by the increasing alienation of capital and profit from the place, moment, and location of production. An abstraction of abstraction swirled around and intoxicated capital.

Concerted attacks on the welfare state began as did the first breakdowns of the postwar drive toward universal advanced education. The universal became synonymous with fascistic concepts of an underclass. The universal was for *them*, not *us*. Postwar social housing was aging. The first renovation cycle of social housing had silently passed by, leading to abandonment, destruction, and decay. In Europe, there had been a failure to provide a bounding and punctuating context of shops, bars, and social centers. Where they did exist, they were the first to go. The aging of postwar social housing went alongside attacks on the welfare state. Attempts would now be made to break it down completely and suggest the idea that a social service should function like a market.

Everything was connected to battles over work, life, and labor. The logic of the soft revolutions involved new relationships to consumption. The acceleration of technology made political control into a complex framed by personal devices offering the lure of bypass via the interface. Bypassing became a desire. Attempts to break down control created a permanent neoliberal crisis. Asset stripping had already set everyone up for a final deregulation of capital. Business had already committed suicide in its rapid desire to break itself down in pursuit of shareholder value.

Battles between generations took new synthetic forms. Earlier youth identities claiming new ones were parodic or insincere. A revolt against earlier youth movements used similar tools to those that had been used before. This was particularly profound in relation to art and its tendency toward extended adolescence. Art began to mirror rather than critique popular culture—through the way it was realized rather than by what it produced. A cycle of restarts began to move with increasing speed from 1974 onward: capitalizations of the recent past and near future.

So what are the application effects that point forward from 1974? Art as pseudodocumentary became an extension of self-commentary. An increasing mockery and parody of authority developed alongside endurance as a marker—endurance as a last-ditch attempt to force difference into play. A combination of self-awareness was being reported by the artist alongside the rise of parodic documentary strategies to replace a weakened and increasingly absurd fourth estate, which was devastated by the development of a twenty-four-hour news cycle and the proliferation of communication. The enduring idea of tribal youth identities had led to a continued mockery of authority, including the sobriety of recent neo=avant-gardes. Endurance was the key—endurance as an artist—endurance as a marker of something that stood in disinterested tension with earlier certainties and

modes of analysis. So we saw the introduction of the voice of the artist as a self-commentator. This was initially accelerated through feminism and challenges to heteronormativity. It was necessary to provide explanations of difference. The work became a demonstration of difference. Work became a representation of outsideness and otherness. The voice of authority was replaced by a proliferation of voices providing communication, explication, and the narration of self-awareness. This was combined with the rise of the supersubjective and with the celebration, appreciation, and redirection of traditional means of expression. Craft became a marker of resistance and a celebration of historically marginalized activities. Design—the everyday introduced into the space of art—became an antihierarchical marker of the eviscerated present bypassing the truth claims of earlier avant-garde groupings. What had been excluded became what is subjectively true. Posturing became important within the frame of collective protest. Playing up and parodying as performance connected to the rise of the artist as an acritical presence within and outside protest simultaneously. The artist danced around the edge of other people's certainty and demonstrated self-consciousness and affected distance in a super-self-aware manner.

The year 1974 left us with a profound skepticism of organization, not just earlier attempts to collectivize, organize, or even unionize artists but the rejection of structures completely. The skepticism of structures involved replacement by temporary inclusion in events. This led to the consortium or cartel model. Artists began working together when necessary. Anything dynamic had to accommodate differences that could never truly be understood or resolved. A commitment to collectivity without collective values—all connected to the notion of an artist as one part of a larger body. The artist was an individual who had no obligations or ethics outside the body of art. Feelings of exclusion from the body and separateness from the contemporary produced the conditions for a contingent swarm.

The use of technology as a form of production was critical here. The replacement of artistic innovation with the deployment of new tools. Constantly revealing new mechanisms to break down mediation. Tools appeared in the process of their description. The unpacking and collaging of technology began. Technology became a form of production—it was not a tool toward production. Technology was deployed—technology did not produce. Art became a commentary not on its own materiality but on the conditions of exchange around production technologies—including painting. From 1974 onward, we saw a reduction in the authority of labor and a concurrent increase in discussion about the reception and social value of work, a constant dilemma and flow of meanings. There was a reduction of significance of any single work in and of itself. These awarenesses moved permanently in relation to one another. Art's limits could be acknowledged by demonstrating a consciousness of its limits, leading to the rise of new formalisms via process as a means of articulating defeat without surrendering. This led to the production of infinite familiar advanced art forms through the adoption and corruption of processes that might produce their own deskilled aesthetic. The artist was no longer in control of unlearning: the bad painting was not a record of truth or nirvana.

Art was no longer a willful rejection of craft or skill or the suppression of the same for democratic or horizontal reasons. Traditional distancing devices were of no use either, for no distancing was possible any more. Distancing always revealed hidden power codes and lingering authorities. You could no longer create a distance from anything. The more distance you tried to create, the more hidden power codes would be revealed. Artists turned to other models, parallels, and relations as a way out. Contemporary art took over other disciplines and attempted to render them subdisciplines of contemporary art. Everything is consumed, and everything is produced.

One answer seemed to be the recuperation and reiteration of earlier modernist certainties. Starting in 1974, reiteration and recuperation became necessary in the face of shifts in criticism and critical consciousness away from the object and toward the structures of meaning and exposition that surround the object. Artists turned to the recuperation and reiteration of other forms and structures in order to become part of these processes of analysis. Contemporary critical practice therefore created alternative and parallel histories. Art became a recuperation of its own forms and reiterations in solidarity with both the self and the infinite other. Art now sought, with increasing speed, what had been overlooked or misunderstood. From 1974 onward, there was an attrition of conceptualism into degraded forms. Conceptual art had not merely been based on the sharing of an idea; it was a regime of self-consciousness and a possession of critique. Yet it soon became merely the forming of an idea, with a reduced presence of artist or object. The attrition of pure conceptualism was attributable to the fact that it excluded histories and identities. Its claims to universality led to a complete rupture in contemporary art and the inability of the contemporary to survive as a coalition in the face of the crisis of criticism and the emergence of the curator. The artist was left standing while a parallel tension between the critical and the curatorial became the dynamic engagement. Contemporary art had reached its recognizable form. There was a total break in terms of its potential. It could not work anymore as a coalition; it had become a swamp. There were too many stresses between the critical and the curatorial. The framing language around art fractured. While from 1974 we saw the beginnings of concerted attempts to evade contemporary art—a push to avoid inclusion within the overwhelming amoebal mush—each attempt was swamped, celebrated, or included into an ever-broader lexicon of the possible.

Art at this point became a recognizable reflection of critical, philo-sophical, and social misreadings. These misreadings defined the artist's starting point, yet they were also the artist's conclusions. Art became a compression and constant flipping of starting points and endgames, a constant exchange of misunderstandings of what is an inference, a pro-jection, a reflection, a reiteration, and a recuperation. By 1974, there was to be a conception of contemporary art history. This generated stress that imploded inside contemporary art and moved it closer to its own legacy as a series of distracted self-awarenesses. Contemporary art history studies itself often creates a battleground of the pseudoethical in lieu of anything else to describe. A series of misreadings are now layered on a series of art practices, and vice versa. This takes place in tension with the curator as a maker and coproducer. The superaware curator is conscious of all other curators in the world. Finding out—in itself—has become curating. The contemporary curator at their highest point is in a permanent state of find-ing out. Finding out things that no single artist can know. Making con-nections that no single artist can make. Curators now connect artists, who cannot link to one another. We are in a period of competing speeds. As with the automation of production and the battle over time between the state, organized labor, and industry, we have competing speeds of produc-tion, consumption, and analysis. Considering curating, academic flow, and artistic production, curating is fast and everywhere, and academic flows are speeding up, whereas artistic production functions at multiple contradic-tory speeds—being contingently useful at points of convergence. All are heading in different directions and looping back over the others. Three distinct tempos operate with multiple contradictory meandering trajecto-ries. Nothing can be resolved, but there are moments of intersection. The fast and everywhere, the slow and distanced, and the alone together meet

one another at multiple points, for fleeting moments and toward flashes of comprehension.

The curator, historian, and critic are super-readers of positive critical presence within a disinterested frame. An ethical battle has replaced liberatory drive. Disappointment is articulated on a grand scale. The desires of the curator, the historian, and the critic point toward something that they cannot imagine and that they explain cannot be produced. Gatekeepers are everywhere. We are on an eighteenth-century middle European toll road. But gatekeepers can be bypassed: you can sneak past in the night, you can distract them, or you can induce them to turn a blind eye. Gatekeepers demonstrate new routes by default, through their claiming and marking of territory. A proliferation of states swamped by an increasing pile may only appear legible as a series of signs poking out of the mire—but the borders are down there, too deeply sedimented to define.

The Experimental Factory

Maybe we're trying catch a moment, maybe an earlier moment, maybe it's a Volvo moment, June 17, 1974, when the view from the factory was of the trees and the way to work together was as a team, and we know that the future is going to work out, that everything is a trajectory as long as we can keep it this way and Ford don't buy the company.

The discursive is wedded to the notion of postwar social democracy. It is both a product of its education systems and subject to its critical potentials and collapses. The European context has surrounded itself with experiment machines in the culture. The discursive framework's success and failure is connected to various postwar phenomena connected to identity politics and postcolonial theory. At the same time, the discursive is suspicious and resistant to the idea of a key protagonist. Without key protagonists, however, it's very hard to know what to do, when to occupy, and when to function. However, the lack of leading voices does permit the discursive to evolve and include.

For those who grew up in postwar Europe, notions of group work were embedded in educational systems. From preschool playgroups through the

organizing structures of management, with group discussion and team-work, we find a set of social models that carry complex implications for people who think they can create something using a related if semiautono-mous methodology.

One of the reasons why I think the factory needs to be looked at again is that the factory—as a system—allows you to look at relationships in a totalizing way. To create a continual map of productive potential, and one of the great struggles of the twentieth century in industrial terms, has been the struggle between speculation and planning. We can say that specula-tion won and that the rhetoric of planning has become something we do for the people we don't know what to do with. We plan for them, but everyone else should speculate. The factory model is of structural use, in the sense of the planned quality of a factory, despite the fact that the factory is always the playing field of the speculative. The myth is that speculation lures production, it lures industry, it lures investment, and is always caught, psychologically and philosophically, in a dilemma. To activate speculation effectively, you have to plan.

The discursive is a production cycle rather than a fixed performative moment in time. Instead of a permanent association of free(d) time, it uses certain production analogies in relation to what could be useful.[1] It occu-pies the increasing gap between the trajectory of modernity (understood here as a flow of technologies and demographic developments) and the somewhat melancholic imploded self-conscious trajectory of modernism. It is within this zone that we can explain the idea of no surprise, sudden returns, and the acceptance of gains and losses as symptoms and catalysts simultaneously. It is here that we can build contingent critical structures that critique both modernity and its critical double.

I have worked on the "Volvo Question" for a few years. Most of my research on Volvo was via Brazilian academic papers concerning the legacy

of 1970s production techniques in Scandinavia and the emergence of models of flexibility, collaboration, and the idea of a better working environment in an ideally productive post-Fordist situation. There has been a synchronization of desire and structure. In the last ten or fifteen years, discursive, fragmented, atomized, content-heavy art projects have somehow freed themselves from classical ideas of the problem of commodity culture and taken on the deep structure of work and life. In the Volvo factory you can see trees while you are making the cars. But you are still making cars, never taking a walk in the woods. Where are the models for contemporary art production in the recent past? Is it Volvo, is it the collective, or is it the infinite display of the supersubjective? And do these factors share similar cultural DNA? The idea of collective action and the idea of being able to determine the speed with which you produce a car, whether you produce it in a group, or individually, or at night, or very slowly, seems close to the question of how to make art over the last fifty years. What happened at Volvo was that people ended up creating more and more free time, and during that free time they talked about ways to work faster. The trauma and attractiveness of infinite flexibility leads to the logic of redundancy, both in the cultural sphere and the traditional productive sphere. Ford bought the company and reintroduced the standard production line not because it was more efficient in pure capitalist terms but because it reclarified relations of production.

The discursive framework works in sync with theories of immaterial labor.[2] The idea that prior to being manufactured a product must be sold is a dominant visible feature of certain developed late-modern art practices. The discursive is a negotiation and demonstration of immaterial labor for other ends. The study of immaterial labor accounts for the blurred factors that surround and produce commodity value. Immaterial labor is the set of factors that produce the informational and cultural content of a commodity.

The discursive makes use of theories of immaterial labor in order to escape simplistic understandings of production within a cultural context. It is at the heart of developments in post-Duchampian art.

The experimental factory is a dynamic paradox—in the Soviet Union every large city had an experimental factory; at Magdeburg today, they have an experimental factory—a model for the experimental, but with no experiments. The idea of the experimental factory or workshop remains a dynamic legacy within the notion of productive cultural work. The postwar social project activated compromised forms of earlier idealized modernisms and created a mesh of alleviated working circumstances that left behind the experimental factory as an attractive model of potential. The factory that exists but does not produce. You can draw a parallel between the rise of the experimental factory as a functional promise and the way critical cultural exhibition structures developed alongside this—without even considering the common phenomenon of occupying abandoned plants of the recent past as the site of art within a program of regeneration in the mainstream contemporary art context. The discursive is packed with projections and traces of postwar social desire. The decentered quality of critical art practices meets an anxiety about the combination of the localized and the internationalized. This contradictory quality is exemplified in the discursive frame's displays of the local to the international within the context of globalized cultural journeys, and vice versa. The discursive offers the potential for art to operate within smallish groupings out of sync with contemporary circumstances yet deeply embedded within its values and flows. This has a lot to do with coalescing smallish groupings that then play out a suspension of aims and results within a context of indifference and projected future meetings. If we accept the postwar period as a closed period, we have to think harder about whether the discursive is merely a gesture toward the recuperation of ideas, places, and values. The

discursive frame may merely be playing out various recuperative projects that are tacitly encouraged within a terrain of closure and globalization simultaneously.

Again, the potential of the discursive framework is a combination of the *out of reach* and the *too close* simultaneously. Art functions as a structural parallel to the dilemmas of contemporary work.

Nostalgia for the Group

Maybe it's possible to explain the discursive cultural framework within a context of difference and collectivity, "difference" being the key word that defines our time and "collectivity" being the thing that is so hard to achieve while frequently being so longed for. We have to negotiate and recognize difference and collectivity simultaneously. It is an aspect of social consciousness that is exemplified in the art context. Difference and collectivity as social definitions and processes of recognition feed from the examples of modern and contemporary art. Art is nurtured and encouraged in return via cultural permission to be the space for what cannot be tolerated but can be accommodated under the conditions of neoliberal globalization.

Difference and collectivity are semiautonomous concepts in an art context. The logic of their pursuit leads us to the conclusion that we should destroy all traditional relations of production in order to encourage a constant recognition of disagreement and profoundly different aims within a context of desire. The focus of the discursive is more on the aims and structural efficacy of the cultural exercise than on what is produced. In turn,

what is produced operates in parallel, unfettered by the requirement to be the total story.

So all of this is problematized by the idea of nostalgia for the group. Art provides a reflection of values, yet within the discursive this is inextricably related to role playing as part of an educational legacy of cooperation. We are sometimes in thrall to structures from the recent past that were not supposed to be a model for anything. Some of the structures that we use, as cultural producers, echo a past that was part of a contingent set of accommodations and dynamic stresses within the postwar social project. And around this there remain old relationships of production that still exist outside complex theories of the postindustrial that are at the heart of postwar developed societies. The discursive thrives when we are increasingly alienated from sites of traditional production owing to the displacing effects of globalization and the increasing tendency toward infinite subcontracting. Struggles over ideas at the site of production still exist, but they are constantly displaced and projected—the struggles are reported but are sometimes resistant to identification across borders within a context that offers an excessive assertion of specificities and tense arguments on the left about how to accept difference and protect the local.

We can see how this developed and left traces in the culture. Consider the history of the French Groupe Medvedkin, who made films between 1967 and 1974 in the context of factories and other sites of production. They worked, filmed, and agitated at the Lipp watch factory in France and subsequently in the Peugeot factory in Sochaux. What you see very clearly in these films is a shift that is mirrored in the dominant art context. From today's perspective, when looking at one of their films shot in 1967 you cannot see any superficial or linguistic set of differences between the people who are running the factory, the people who are working in the factory, and the people who are criticizing the factory from the outside.

They are from the same culture. Physically, they look the same as one another. There are detailed differences that can be determined, but these are nuanced and require acute class consciousness from the perspective of the early twenty-first century. The effects of postcolonialism have not yet shifted the source of cheap labor from the various colonies to the neighborhood of the consumer. But by 1974, the film *With the Blood of Others* opens with a group of longhaired activists wearing old military jackets standing outside the factory gates. They are attempting to play as a brass band to a group of silent, clearly embarrassed, primarily North African immigrant car workers. Through this series of films you see a clarification and separation of aesthetics in terms of identification, language, and techniques of protest. Simultaneously, you see a clear drop in easy communication. Modes of address have separated. You have different groupings talking, but only within each group. Each group has developed a sophisticated role-playing function in relation to the others. They demonstrate "positions" to the others. This shift toward the notion of a public faced by a complex display of self-conscious role playing is familiar within an art context. It does not lack insincerity; it does not lack genuine political engagement; it is a functional parallel.

The question is how to develop a discursive project without becoming an experimental factory and without slipping into a set of conditions that lead to certain redundancy. It is the attempt to hold the collective on this brink that energizes the discursive context. We have created the conditions for the experimental, but no actual experiments. Or vice versa. The discursive is peopled by artists who increasingly accept a large number of permanently redundant citizens and who have come to terms with the notion of the permanently part-time worker in the face of the permanently educated artist. Microcommunities of redundancy have joined together to play with the difference between art time and work time.

The discursive is linked to the question of who is managing time. We have to address the reduction of leisure as a promise and a marker in the postwar period. My grandfather's questions always concerned what I would do with all the leisure I would have in the future. And the question now is: how do you know how much leisure you are having? The museum and the art center are connected to the leisure-promise legacy and connected to a democratization of style. Control of time was traditionally the dominant managerial tool and rightly challenged. Self-management has subsequently become generalized in a postindustrial environment. It's the way even mundane jobs are advertised now. The idea has been put forth that it is essentially better to manage your own time within a framework that involves limitless amounts of work, with no concrete barrier between working and nonworking. This is something that underscores the discursive frame. It is the potentially neurotic, anxiety-provoking situation we find cultural producers operating within. This is something that has superficial advantages and clear disadvantages. The notion of permanent soft pressure, which finds form via the computer and digital media—a soft pressure to manage your own time in relationship to broader networks.

The discursive demonstrates a neurotic relationship to the management of time as a negatively activated excess of discussion, discourse, and hanging around. So maybe we have to think about revised languages of production within the context of self-management. The rise of teamwork and networks is linked to the denial of the location of complex and disturbing old-school production relationships that still exist as a phantom for progressive thinkers. Discursive art contexts are intended to go beyond an echo or mirroring of simple relations of production via small, multiple, flexible groupings, but they are subject to the same complexities that afflict any self-managed environment, even when they refuse to create a timetable.

The shift is away from common ground between people to common ground between what is produced and toward the idea that if we ignore things and follow an ideology instead then something will happen. One of the great potentials of art in the culture is that it attends to structural factors. At some level it reinvents or reconfigures structure. The discursive field attempts to escape by providing the potential to identify critical positions in a structural or general way rather than reproduce commodity anecdotes within the artwork itself. But, as I just said above, it is peopled by those who increasingly accept a large number of permanently redundant citizens and who have come to terms with the notion of the permanently part-time worker in the face of the permanently educated artist. Within the discursive, the notion of self-improvement is ideologically specific; it comes with a philosophy connected to postwar power structures. The notion of continual and permanent education is used in different cultures in order to escape what are actually clear political differences to do with class, situation, and power. It is the promise to the poor child as a way to get out of bad conditions. Working situations are not changed; the idea is that *you* have to change. The notion of flexibility within the workplace is a way to encourage people to rationalize their own disappearance or redundancy when necessary.

Why Work?

Art is a place where the rules of engagement are open to question. Art is a history of doing nothing and a long tale of useful action. It is always a fetishization of decision and indecision—with each mark, structure and, engagement. This book's challenge to contemporary practitioners, or current artists, is that "contemporary art" no longer accounts for what is being made; it no longer is connected to what we have all become rather than what we might propose, represent, or fail to achieve. The challenge made is that artists today, whether they like it or not, have fallen into a trap predetermined by their existence within a regime that is centered on a rampant capitalization of the mind.

The accusation is that artists are at best the ultimate freelance knowledge workers and at worst barely capable of distinguishing themselves from the consuming desire to work at all times; they are neurotic people who deploy a series of practices that coincide quite neatly with the requirements of the neoliberal, predatory, continually mutating capitalism of the every moment. Artists are people who behave, communicate, and innovate in the same manner as those who spend their days trying

to capitalize every moment and exchange of daily life. They offer no alternative.

The notion of artists as implicated figures has a long history, one located in varied historical attempts to resolve the desire to examine high culture as a philosophical marker with the unresolvable problem that the notional culture examined is always out of sync with the function of a high-cultural projection. This means that the accusation that we are functioning within a milieu dominated by predatory neoliberalism is based on a spurious projection of high-cultural function in the first place and cannot account for the tensions in art that remain: the struggle for collectivity within a context that requires a recognition of difference. Theories of immaterial labor—an awareness of the informational aspect of the commodity and the cultural content of the commodity—have had a profound influence on the starting point of current artists, offering an awareness of the accusation framed by the doubts and consciousnesses that form the base of the work. As a result, the question *What is the good of work?* is the heart of the work—it is not a symptom or accidental proximity. It accounts for the doubts and confusions that exist and explains why there seem to be moments of stress and collapse within any current art structure. These moments of critical crisis are an expression of resistance to the structure— a constant restructuring in response to the desire to avoid work within a realm of permanently unrewarding work.

The question *Why work?* rather than *What is the good of work?* aligns dynamic current art with its critical potential. The fact that it is superficially hard to determine observable differences between the daily routines and operations of a new knowledge worker and an artist is precisely because art functions on a track closely parallel to the structures it is critiquing.

It requires precise and close observation of the production processes involved in order to differentiate between knowledge workers and current

artists. If the question *Why work?* is the original question of current art, then to counter the accusation that artists are in thrall to processes of capitalization that are beyond them it is necessary to look at a number of key issues around control and to address them in a fragmented way. The following negotiation of these key issues is necessary in order to replace a critical mirror with a window.

So what happened to the promise of leisure? Maybe this is what art can offer us now—a thing to use or reflect upon in a zone of permanent future leisure—as the *arts* as an instrumentalized deployment becomes a more refined and defined capitalized zone, a zone never geared toward artists alone but instead directed toward the population in general as a way of rationalizing and explaining away innovations within the workplace as part of a matrix of doubt and difference. Artists here are viewed as content providers for the leisure zone rather than exemplary of it or in a critical relationship with it; they are terminally cast as outsiders who are nevertheless providing exemplary lifestyle models by their very nature. Yet the existence of a leisure promise is not synchronized with artistic production. Modes of leisure have been adopted by artists as a way openly to counter notions of labor as sites of dignity and innovation and in order to critique, mock, or parody the notion of an artistic life as a role-play within the leisure zone. The withdrawal of labor or the establishment of structures where intentions and results are uneven are all markers that go beyond the promise of postlabor, a promise that was always nothing more than the projection of a neurotic nonstate.

So, are we left with the possibility of the good artist who fulfills the critical criteria? The artist who works—sort of permanently—and always finds a way to account for him- or herself within an ever-hungry context that demands more and more interpretation? It's not leisure, but it's not really work.

Within this subset we have to engage in a careful process of categorization, meaning that we have to look at the methodological groupings that emerge within the art context rather than at what is produced.

One answer over the past few years was the formation of communities of practice forming new leisure/work modes. Artists are often creating new life in opposition to lifestyles. A complete reorganization of relationships may occur, where relationships themselves become the subject of the work and discursive models of practice become the founding principle rather than a result or product.

On the opposite extreme, there is deliberate self-enforced isolation and a concurrent lack of accountability, which is used as a structural game within a context where notional support structures are mutable and dynamic. The two main tangents of current art both attempt to release us from the accusation. Restructuring life (ways to work) and withdrawing from life (ways to free work).

Categorizations of art in this case can superficially appear to mirror attitudes to work. It is quite appropriate for artists to co-opt working models and turn them to their own ends, from the factory to the bar, or even to the notion of the artist's studio as a specific site of production that either apes or mimics established daily structures or deliberately avoids and denies them. Categorizations of art are not limited to what is produced but are connected more deeply to how things might be produced. It is the requirement to understand a focus on production rather than consumption (including the new formalism of responsible didactic criticism) that unlocks art's potential and permits a recasting of the accusation.

A marker for the accusation is the creation of your own deadlines versus the apparent creation of acquired deadlines. The notion of a deadline is a crucial applied structure that links the accused with the flexible knowledge worker. Deadlines increase exponentially and are created by the producer as

much as they are applied. A possession of consciousness of the constructed deadline permits engagement and disengagement in order to create a zone of semiautonomy.

Working for a long time with only some deadlines is a prerogative of the artist and the occasional worker who functions within a job description of unbearable tedium but hard-won rights over terms of employment. It is the tension between the notion of applied flexibility and a critique of flexibility that permits a projection of potential.

Observing versus living is the most profound difference here. The notion of endlessly observing rather than taking part links the artist with the ethnographer and the alien. It is this continual flow between states of engagement and disengagement that provides the potential. It is in this gap that we can understand *why it is produced* rather than *what is produced.*

Relationship with others is crucial. The constant daily casting of roles—alone together—alone together over and over again. For artists do not operate in isolation. And artists can only function in complete isolation. The acquisition or rejection of relationships is a crucial marker in an art production that defines an artistic practice over and above a superspecific knowledge-producing activity peppered with deadlines. This means that the entry of the artist into the apparently undifferentiated territory of infinite flexibility is made critical by a recognition of a series of encounters, borders, humps, and diversions.

The identification of ethical barriers emerges when making art under the stressed circumstances of the accusation. Circumstances and subjects appear as moral zombies—undead and relentless victims—which artists reject or accept in tension with the creation or rejection of ethical barriers. Ethics are not stable or easy to reach, feed, or kill off. Under these stressed circumstances there is an assumption that art extends memory forward and backward. In other words, art is not necessarily synchronized to the

present. What appears to be a methodology linked to present works is an illusion. Art deploys flexibility in order to account for the moral zombie—in order to navigate the terrain of ethical mutability. Art extends and reduces memory using tools that were only developed to shorten memory, that is, capitalize the near future and recent past. As there are no limits to work, there are also no limits to not working. The idea that artists find a way to work is a defining characteristic of current art, but it is an idea that always takes place as a setting for postlabor anxieties and the creation and dismantling of ethical barriers.

Research and reading as activities are not accounted for in the accusatory model. Artists working in a research mode as a primary method of production are assumed to be the *good* workers. To research in a directed way and then present this as a final work is not a leisure pursuit.

But accounting for things and relationships in the world leads to displaced work—the creation of structural subjects. There is a sense in which all new art made accounts for all the other work made. This awareness is not necessarily accompanied by full knowledge of all the other work but by a sense that there are all the other works.

Even in documentary work there is a sense of questioning the nature of art as well as a sense of creating didactic structures or replacing a super-self-conscious and worn-out fourth estate. The pursuit of documentary strategies is also a critique of the flows and capitalist logics that are applied to the commodification of art.

This leads us to the equation: "just another citizen in the room" versus "everything I do is a special perspective on the specificity of others." At the heart of this artistic persona is the assertion of citizenship combined with an invitation to view the extraordinary ordinary.

This makes the biographical a locus for meaning. As art became more specific, the biographical became both more generic and more special, a

way to present the specific in a form that would encourage more specificities and more difference. Art now is an assertion of difference, not an assertion of flexibility. Artists function in microcommunities of discourse that are logical and contingent within their own contexts. These are often generation related. Current artists are caught within generational boundaries.

The notion that artists are a perfect analogue for the flexible entrepreneurial class is a generational concept that merely masks a lack of differentiation in observation of practice and the devastating fact that art is in a permanent battle with what came just before. That is the good of work: replacing the models of the recent past with better ones.

The notion of the withdrawal of production or limiting production is the key to decoding the anxiety about work. One of the enduring powers of art and devices used by the contemporary artist to consolidate specificity once he or she has attained a degree of recognition is a withdrawal of labor or a limiting of supply. Doing the opposite—that is, operating freely, openly, and on demand—is viewed as a problem within the gallery structure and resists the simple commodification of art. This shift to production consciousness by current artists and away from reception consciousness by contemporary artists is a form of active withdrawal.

This notion of withdrawal can be understood in relation to the following: Are there answers or questions in the work? This is central to the defense against the accusation. A postmodern understanding is that the current artist asks questions of the viewer while standing beside them. It is this sense of art as something that asks questions of the viewer that is misunderstood in the knowledge-worker accusation. The shift of position from confrontation to proximity is a category shift in practice. Within the realm of the knowledge worker the new consumer is always activated and treated as a discriminating individual who can be marketed to

directly—spoken to face to face. Documentary practice moves the user and the producer alongside each other. The exhaustion created by the continual capitalization of the recent past and the near future is based upon a sense in which the knowledge worker is trying to account for every differentiation, whereas the artist is producing every differentiation alongside the recipient of the work.

This is linked to a play with control over the moment of completion. The moment of judgment is not exclusive to an exterior field in the case of current art. This sense of control or denial is the zone of autonomy within a regime of excessive differences.

The documentary is permanently working off other fields and gives the potential of being arrested while thinking about art. This is not possible while working as a knowledge worker.

Current work undermines a sense or possibility of infinite leisure. Infinite leisure is only one form of religiously based utopia. A nightmare full of virgins and mansions. Will there be dogs? Oh, I hope there are dogs! To be a clerk would be heaven for some people. A breakdown of the barriers between work, life, and art via direct action is a rather more rewarding potential. Art appears to be result based, but it is generally action and occupation based. It is toward something. It reaches out. It only has meaning within a context, and that context will always determine what activities might be necessary to improve the context.

This leaves us explaining everything while suffering from a total communication anxiety about differentiation. Art viewed as a generalized terrain of collectivity and difference operates within a regime of anxiety that is merely a reflection of multiple, apparently contradictory moments of differentiations chiming simultaneously. Anxieties about too many artists, over production, and over a lack of ability to determine quality are all ideologically motivated statements that defer to a defeated series of authorities

who would prefer either the attainment of a neoutopian consensus, a market consensus, or at least the consensus of the regime of a Big Other. All of these things are attacked and permanently defeated within current art. Otherwise things will default toward authority and control. The entropic quality of art's structural and critical trajectory is its resistance.

This is because the relation between the development of creative tools for decentralized production and art production is also a historical coincidence. It is necessary to look at what is produced only through the primary defensive mesh against predatory capitalization—its structural approaches to tools that may well have been developed for other purposes.

Art is not a zone of autonomy. It does not create structures that are exceptional or perceivable outside the context. Therefore current art will always create a sequence of problems for the known context. One of those context sets is the undifferentiated flexible knowledge worker who operates in permanent anxiety in the midst of a muddling of work and leisure. Art both points at this figure and operates alongside it as an experiential phantom of the context.

Art is a place where the rules of engagement are open to question. The knowledge worker also appears to challenge rules of engagement but can only do so within the context of preexisting software tools or within a set of new fragmented relationships. The artist can create alienated relationships without these intricacies.

A different sense of *super-self-conscious* commodity awareness is at the core of current art's desire to come close to the context. Projection and speculation are the tools reclaimed in order to power this super-self-conscious commodity awareness. Artists project into the near future and the recent past to expose and render transparent new commodity relations. The surplus value that is art is not limited to its supposed novelty value but is embedded in its function as a system of awareness.

Art is a series of scenarios/presentations that create new spaces for thought and critical speculation. The creation of new time locations and shifted time structures actually creates new critical zones where we might find spaces of differentiation from the knowledge community. For it is not that art is merely a mirror of a series of new subjective worlds. It is an ethical equation where assumptions about function and value in society can be operated upon. There is no art of any significance in the last forty years that does not include this as a base-level differentiating notion.

The idea of the first work or the development of ideas is not toward the total production of all work in the future any longer. This creates anxiety within the culture in general and leads a search toward analogous structures that also appear to function temporarily with contingent projection. A sense of constant returns to ideas or structures by choice rather than intuition is this aspect of contemporary art that defies the logic of capital. The notion that an artist is obsessed by a structure or an idea's context is sometimes self-perpetuated. The apparent work is no more than a foil or mask to a longer deferral of decision making. The art becomes a semiautonomous aspect of lived experience for the artist as much as the viewer.

Working alone but in a group is a contradiction at the heart of current art practice. It is always an activated decision to give up the individual autonomy of the artistic persona toward working together. Within the flexible knowledge community, the assertion of individual practice has always to be subsumed within the team-worked moments of idea sharing.

Art as a life-changing statement is always a specific decision that is connected to entering moments of judgment that cannot be controlled exclusively by the artist but are also operated upon by all other artists. The them and us is me and us and us and us and them and them. Not thinking about art while making art is different than not thinking while preparing a PowerPoint presentation on the plane. Of course I am working, even when

it looks as if I am not working. And even if I am not working, and it looks as if I am not working, I still might claim to be working and wait for you to work out what objective signifiers actually point toward any moment of value or work. This is the game of current art.

Art production/work methods are not temporally linked or balanced because the idea of managing time is not a key component of a personal or objective profit motive for artists, unless they decide that such behavior is actually part of the work itself.

The assumption that there is a *they* or *them* is part of the problem in understanding how artists function within society. Artists are also *they* or *them* who have made a specific decision to operate within an exceptional zone that does not necessarily produce anything exceptional. Adherence to a high-cultural life is a negotiated concept within the current art context.

This critical community is subject and audience simultaneously. Therefore, we have the situation where an artist will propose a problem and then position it just out of reach precisely to test the potential for an autonomy of practice.

Reporting the strange in the daily: what cannot be accounted for is at the heart of artistic practices—yet not for purposes that can be described outside of the work itself. And still, working less can result in producing more. The rate of idea production within art is inconsistent—which is a deliberate result of the way art is produced and how it can become precise and other—even while it too flounders and proudly reports back to us within the self-patrolled compound masquerading as a progressive group think-tank.

Near the beginning of his 1993 film *Caro Diario* [*Dear Diary*], Nani Moretti is sitting in a cinema watching a bourgeois dinner party peopled by weary disillusioned couples. They are talking about where it all went wrong from a perspective of success and authority.

Why Work?

One dinner guest turns to another.

"You shouted awful, violent slogans. Now you've gotten ugly."

Moretti has finally had enough and angrily addresses the cinema screen.

"Why all? Why this fixation with us 'all' being sold out and co-opted!"

He continues.

"I shouted the right slogans, and I'm a splendid forty-year-old."

"Even in a society more decent than this one, I will only feel in tune with a minority of people. I believe in people, but I just don't believe in the majority of people. I will always be in tune with a minority of people."

Notes

Introduction: Creative Disruption in the Age of Soft Revolutions

1. *Of Human Bondage*, dir. John Cromwell, RKO Radio Pictures, 1934; W. Somerset Maugham, *Of Human Bondage* (London: George H. Doran Company, 1915).

2. These lectures were: "1820: Erasmus and Upheaval" (February 26, 2013), "1948: Skinner and Counter-Revolution" (February 28, 2013), "1963: Herman Kahn and Projection" (March 5, 2013), and "1974: Volvo and the Mise-en-scène" (March 7, 2013), all at the Miller Theatre, Columbia University, New York.

3. These works include various artworks and texts: Liam Gillick, *McNamara* (1992); *Erasmus Is Late* (1995); *Discussion Island/Big Conference Center* (1997); *Literally No Place* (2002); and *Construction of One* (2005).

4. Michel Foucault, "About the Beginning of the Hermeneutics of the Self: Two Lectures at Dartmouth," *Political Theory* 21, no. 2 (May 1993): 198–227; Michel Foucault, *On the Genealogy of Ethics: An Overview of Work in Progress*, in *The Foucault Reader*, trans. Paul Rabinow (London: Penguin, 1991).

5. Jacques Derrida, *The Truth in Painting* (Chicago: University of Chicago Press, 1987).

6. Michel Foucault, *Hommage á Jean Hyppolite* (Paris: Presses Universitaires de France, 1971), 145–172. English translation by Paul Rabinow, in *The Foucault Reader*, 76–100.

Notes

1. Contemporary Art Does Not Account for That Which Is Taking Place

This essay was developed during a week long seminar at Columbia University, School of the Arts, in October 2010. Special thanks to Robin Cameron and Ernst Fischer for the use of their notes of the week's work.

1. Liam Gillick, "Why Work," *e-flux Journal* 16 (2010); Liam Gillick, *Why Work?* (Auckland: Artspace, 2010).

2. "This questionnaire was sent to approximately seventy critics and curators, based in the United States and Europe, who are identified with this field. Two notes: the questions, as formulated, were felt to be specific to these regions; and very few curators responded." Hal Foster and the editors, "Introduction: Questionnaire on the Contemporary," *October* 130 (Fall 2009).

3. The term does not appear in Donald Judd, "Specific Objects," *Arts Yearbook* (1965), and is studiously avoided elsewhere in his writing.

4. See *Carnegie International Artists Bios*, 2004/2005: "Two digital video works by Paul Chan engage us in the dual passions that are at the center of his world: art and political activism." Other references include MoMA, *PS1 Board of Directors list* (2010): "artist and activist Paul Chan."

5. E-flux, *unitednationsplaza*, Berlin, 2006–2007; *unitednationsplaza*, Mexico DF, 2008; *Nightschool*, New York, 2008. http://www.unitednationsplaza.org/.

6. Paul O'Neill and Mick Wilson, eds., *Curating and the Educational Turn* (London: Occasional Table, 2010).

7. Correspondence with the author, November 2010.

8. "The big Other is somewhat the same as God according to Lacan (God is not dead today. He was dead from the very beginning, except He didn't know it . . .): it never existed in the first place, i.e., the 'big Other's' inexistence is ultimately equivalent to Its being the symbolic order, the order of symbolic fictions which operate at a level different from direct material causality." Slavoj Žižek, "The Big Other Doesn't Exist," *Journal of European Psychoanalysis* (Spring/Fall 1997).

9. Quoted in Liam Gillick and Anton Vidokle, *A Guiding Light*, Shanghai Biennale (New York: Performa, 2010).

10. Ina Blom, *On the Style Site: Art, Sociality, and Media Culture* (Berlin: Sternberg, 2007).

6. 1948: B. F. Skinner and Counter-Revolution

1. B. F. Skinner, *Walden Two* (New York: Hackett, 1948).
2. *A Matter of Life and Death*, dir. Michael Powell and Emeric Pressburger, Eagle-Lion Films, 1946.
3. *Entartete Kunst*, Archeologisches Institut, Munich, 1937.

8. 1963: Herman Kahn and Projection

1. Betty Friedan, *The Feminine Mystique* (New York: Norton, 1963).
2. Erving Goffman, *The Presentation of Self in Everyday Life* (New York: Anchor, 1959).

10. Maybe It Would Be Better If We Worked in Groups of Three?

1. Jürgen Habermas, *The Theory of Communicative Action*, vol. 1: *Reason and the Rationalization of Society*; vol. 2: *Lifeworld and System*, trans. T. McCarthy (Boston: Beacon, 1981).
2. See Maurizio Lazzarato, "Immaterial Labor," trans. Paul Colilli and Ed Emory, in *Radical Thought in Italy*, ed. Paolo Virno and Michael Hardt (Minneapolis: University of Minnesota Press, 1996), 132–146.

13. The Experimental Factory

1. Pierre Huyghe, *The Association of Free(d) Time*, part of Liam Gillick and Philippe Parreno, *The Moral Maze*, exhibition, Le Consortium, Dijon, 1995.
2. Maurizio Lazzarato, "Immaterial Labor," trans. Paul Colilli and Ed Emory, in *Radical Thought in Italy*, ed. Paolo Virno and Michael Hardt (Minneapolis: University of Minnesota Press, 1996), 132–146.

Index

abstract: concreteness of, 51–55; as destruction, 52; endlessness of, 52–53; endurance of, 55; failure and, 54; minimalism and, 53–54; personal in, 55; replacement objects of, 54; representation of, 51–54; tautology of, 51–52
abstraction, 65
academicization, 3
accommodation, 8–9
accumulation, 17–18
accusations, 123–24
activism, 4, 130n4
aging, 98
amoebas, 17–20
antiquities: authority related to, 25–26; democracy related to, 30–31; tension and, 25–26, 30–31
anxiety, 114; about differentiation, 124–25; in discursive, 81–82, 84; in Europe, 87–88

architecture: corporation and, 42; of modernism, 42; parallel histories and, 29–30; technologies and, 29–30
art fairs, 75
artists, xi; accusations and, 123–24; biography for, 122–23; capitalization and, 117, 119; categorization and, 120; complete curator and, 72; context of, 124–25; control of, 124–25; criticism and, 118–19; deadlines for, 120–21; differentiation and, 124–25; of documentaries, 122, 124; ethics for, 121–22, 126; of exhibitions, 33–34; generation and, 123; immaterial labor of, 118; innovation and, 119; leisure and, 119–20, 124; neoliberalism of, 118; neuroticism of, 117–18; projection of, 125–26; relationships for, 121; research by, 122; society and, 126–28; withdrawal of, 123
art market, 72

art pile: accumulation in, 17–18; chains
 and amoebas in, 17–20; endurance in,
 17; feedback loop of, 19–20; nodular
 subjectivities in, 17; origins of, 18–19;
 philosophy and, 19–20; split and
 fragmentation in, 17–20; stress in, 18;
 supersubjectivity in, 19
ASAP futures, 35–36
audience, 9–10
Austro-Hungarian Empire, 22
authority, 127–28; antiquities related to,
 25–26; resistance to, 22; scientific
 research as, 23–25
autonomy, xiv, 64–65, 126

barcodes, 92
Bauhaus, 41–42
Beagle (HMS), 23–24
behaviorism, 44–45, 49; ecoconsciousness
 and, 43; Skinner and, 41
belief, 24–25
Big Other, 8, 130n8
biography, 10–11; for artists, 122–23;
 in 1963, 66–67
blindness, xiii
border, 87–88
brain, 46

capital, xii, 98
capitalism, 58
capitalization, 117, 119
Caro Diario [Dear Diary] (film), 127–28
categorization, 5, 120
chains and amoebas, 17–20
Chan, Paul, 4, 130n4
circle, xiv–xv

clone, 61
collaborations, 1–2
collective bargaining, 37–38, 44–45
collectivity, 15, 111
collectivization, 37–39
colonization, 23–24, 91–92, 113; national
 identity and, 38; South Vietnam
 and, 60
common land, 32
communication, 73–74; group
 nostalgia and, 112–13; from political
 consciousness, 22
complete curator: arrangements
 of, 76–77; art fairs and, 75; art
 market and, 72; curatorial and, 72;
 description of, 71; dichotomy of,
 73; discourse of, 74–76; education
 and, 73–74; exhibitions of, 74–76;
 language for, 73–74; potential
 paradigm and, 72–73; research of,
 75–77
concreteness, 51–55
conscious agent, xiv
consciousness, 22, 112–13; documentaries
 and, 6–7; ecoconsciousness, 43–44;
 education and, 4–5
conspiracy, 64–65
containers, 40
contemporary, 4–7, 12
contemporary art: blindness of, xiii;
 challenge of, x; definition of, x,
 1–2; endurance of, x; genealogy of,
 xii–xiii; lectures on, xi; philosophy
 and, x; resistance of, xii–xiii; soft
 revolutions and, xi–xiii; use of, as
 term, x, 1–3

Index

contemporary art context: Big Other in,
 8, 130n8; categorization in, 5; Chan
 and, 4, 130n4; contemporary, 4–7, 12;
 contradictions in, 7–8; displacement
 in, 11–12; networking in, 7; parallel
 education in, 5–6; work methods in,
 8–11
contemporary artists, xi
contemporary art meaning, xiv;
 academicization in, 3; current
 art as, 1; differentiation in, 1, 4;
 generalization in, 2–3; oppositions
 in, 1–2; questionnaire on, 3, 130n2;
 specificities in, 2–3
contemporary art museums, 69
context, 8–11; of artists, 124–25; difference
 and, 111–12; of exhibitions, 32; in
 projection, 16. See also contemporary
 art context
contradictions, 7–8
control: of artists, 124–25; through
 belief, 24–25; of patents, 26–27;
 from scientific research, 23–24;
 social class and, 27–28; by U.S.,
 22–23, 26–27
co-option, 6, 120
corporation: architecture and, 42; unions
 and, 43–44
counterculture, 63–64
creativity, xii
criticism, ix–x, 118–19
Cuba, 58
curatorial, 72, 103–4
curators, 66, 103–4. See also complete
 curator
current art, 1

Davis, Bette, ix
deadlines, 120–21
defense, 48–49
De Gaulle, Charles, 57–58
democracy, 44–45, 105; antiquities related
 to, 30–31; society and, 42–43
denial, 4
descriptive potential, 14
destruction, 52, 68
dichotomy, 73
differences, 22–23, 111–12
differentiation, 12; anxiety about, 124–25;
 in contemporary art meaning, 1, 4; in
 discursive, 81
discovery: of technologies, 26–27; of
 Venus de Milo, 25
discursive, the, 79–80; anxiety in,
 81–82, 84; border related to, 87–88;
 differentiation in, 81; parallel in,
 85–86; postwar social democracy and,
 105; projection in, 84; redundancy
 and, 85–86; setting and, 84–85;
 statements in, 82–83; tension in, 83.
 See also experimental factory
displacement, 44; in contemporary
 art context, 11–12; projection or,
 35–36
distance, 101
documentaries, 6–7, 122, 124
doubt consolidation, 2
drive, 10

eco-choice, 94–95
ecoconsciousness, 43–44
economics, 13
ecopolitics, 13

education, 6, 44; complete curator and, 73–74; consciousness and, 4–5; 1948 and, 47–49

1820: government and, 21; parallel histories from, 22–29; revolutions and, 22

embodied awarenesses, 66

empiricism, 24–25

endlessness, 52–53

endurance, x, 17, 50, 55, 99–100

Engels, Friedrich, 22

England, 27, 73

Enlightenment, xii

entrepreneurs, 28, 59–60

ethics, 121–22, 126

Europe, 37, 41–42, 44, 105–6; anxiety in, 87–88; England, 27, 73; U.S. and, 88–89

European Economic Community, 57

European Union, 57–58, 87–88

exhibitions, 47–48, 67; characters of, 33–34; of complete curator, 74–75; context of, 32; free thinking and, 33–34; technology of, 32–33; work as, 49

experimental factory: factory in, 106; globalization and, 108–9; group work in, 105–6, 108; immaterial labor and, 107–8; model of, 108; paradox of, 108–9; postwar Europe in, 105–6; production cycle in, 106–7; redundancy in, 107; relationships in, 105–6

factory. See experimental factory

failure, 54

federation, 87–88

feedback loop, 19–20

Feminine Mystique, The (Friedan), 59

films, ix–x, 45–46, 127–28; in 1963, 67–68; about production, 112–13

flow, 10–11

Foster, Hal, 3, 130n2

Foucault, M., xiii

fragmented and split, 17–20

free thinking, 33–34

Friedan, Betty, 59

Gandhi, Mahatma, 38

gatekeepers, 104

genealogy, xii–xiii, xv, 65

generalization, 2–3, 5

generation, 123

globalization, 108–9, 111–12

government, 21, 63–64

group nostalgia: anxiety and, 114; communication and, 112–13; globalization and, 111–12; parallel and, 113; postcolonialism and, 113; in production, 112; redundancy and, 113, 115; self-improvement in, 115; self-management in, 114; social class and, 112–13; structure and, 115; time and, 114

group work, 105–6, 108

health, 93

Hell's Angels, 39

hiding, 80–81

historical ontology, xiii

history, 3. See also parallel histories

Howard, Leslie, ix

Index

identity, 25–26, 38, 59, 96
identity theories, 59
immaterial labor, 107–8, 118
inclusivity, 2–3, 81
incompletion, 14–15
independence, 38
industrialization, 30
industrial production, 45
industry collectivization, 37
innovation, 119
installation, 3
institutionalized relativism, 22–23
institutions, 76
invention, 26–27

Judd, Donald, 4, 130n3

Lamborghini, 59–60
Land Rovers, 39
language, 73–74
lectures, xi, xiii–xiv
leisure, 119–20, 124
limits, 101
Lind, Maria, 6
location, 46

management, 64; self-management, 63,
 97–98, 114
Marx, Karl, 22
Marxism, 58
materialities, 46. *See also* immaterial
 labor
Matter of Life and Death, A (film),
 45–46
medical technology, 61
military, 40–41

minimalism, 53–54
misreadings, 103
Missouri Compromise, 22–23
modernism, 41–42
Mormon Church, 24–25
multiple self, 61
museums, 32, 69. *See also* exhibitions

narratives, parallel, xiv
national identity, 25–26, 38
nationalism, 27–28
nationalization, 37–38
neoliberalism, 97, 118
networking, 7
neuroticism, 117–18
news cycle, twenty-four-hour, 94–95
new structures, xiv
Ngo Dinh Diem, 60
1948: behaviorism in, 41, 43–45, 49;
 brain in, 46; collective bargaining in,
 37–38, 44–45; democracy in, 44–45;
 ecoconsciousness in, 43–44; education
 and, 47–49; European nationalization
 and, 37; exhibitions and, 47–49;
 location in, 46; modernism in, 41–42;
 singularization in, 38–39; society in,
 42–43; specialization in, 39–40; studio
 in, 48, 50; symbolization in, 39–40;
 technologies in, 39–41; utopia in,
 41–42
1963: abstraction in, 65; biography in,
 66–67; clone in, 61; conspiracy in,
 64–65; contemporary art museums in,
 69; counterculture in, 63–64; curators
 in, 66; destruction in, 68; embodied
 awarenesses in, 66; entrepreneurs in,

Index

1963 (*continued*)
59–60; exhibitions in, 67; films
in, 67–68; genealogy from, 65;
government in, 63–64; group
identity in, 62; identity theories in,
59; Lamborghini in, 59–60; medical
technology in, 61; political unions
in, 57–58; populism in, 68; presented
self in, 62; projection and scenario in,
62–63; pseudoautonomy in, 64–65;
repetition in, 66; self-awareness
and, 60; supercollectors in, 68–69;
surveillance in, 64; time in, 62–63, 65;
video in, 67
1974: aging and, 98; barcodes in, 92;
capital and, 98; curators of, 103–4;
distance in, 101; eco-choice in, 94–95;
endurance in, 99–100; gatekeepers
from, 104; health in, 93; identity in,
96; limits in, 101; misreadings in, 103;
neoliberalism in, 97; pocket calculator
and, 92–93, 95; postwar in, 91–92,
95; recuperation and reiteration in,
102; revolutions and, 95–96; self-
management and, 97–98; skepticism
in, 100; speed in, 103–4; technology
and, 96–97, 101; tension in, 99; time
in, 93–95; tradition in, 100; twenty-
four-hour news cycle in, 94–95
nodular subjectivities, 17
nostalgia, 9. *See also* group nostalgia

objectivism, 6
objects, replacement, 54
observation, 121
October magazine, 3, 130n2

Of Human Bondage (film), ix–x
O'Neill, Paul, 6
Onoda, Hiroo, 91–92, 95
ontology, xii–xiii
oppositions, 1–2

paradigm, potential, 72–73
paradox, 108–9
parallel: in discursive, 85–86; group
nostalgia and, 113; in projection, 15–16
parallel education, 5–6
parallel histories, 22–27; architecture
and, 29–30; industrialization and, 30;
religion and, 31; rights and, 29–30;
secondary individuals with, 29–30, 34;
tension in, 28–30. *See also* control
parallel narratives, xiv
parallel structures, 31–32
participation, 47–48
patents, 26–27
personal, 55
philosophy, x, xiv–xv, 19–20
playback, 60
pocket calculator, 92–93, 95
political activism, 4, 130n4
political consciousness, 7, 13, 22
political unions, 57–58
populism, 68
Porsche, 39–40
postcolonialism, 113
postwar, 88–89, 105–6; in 1974, 91–92, 95
power, 58
production: demonstration of, 32; films
about, 112–13; scientific research
and, 28
production cycle, 106–7

Index

projection, 12, 46–47, 84; of artists, 125–26; ASAP futures and, 35–36; collectivity and, 15; context in, 16; descriptive potential and, 14; displacement or, 35–36; economics related to, 13; ecopolitics and, 13; incompletion and, 14–15; parallel in, 15–16; scenario and, 62–63; simultaneous realities in, 15–16; speculation and, 13–14, 36; supersubjectivity and, 15

pseudoautonomy, 64–65

questionnaire, 3, 130n2

Radical War, 27
radio, 38
realism, 6
realities, simultaneous, 15–16
records, 40
recuperation, 102
redundancy, 126; discursive and, 85–86; in experimental factory, 107; group nostalgia and, 113, 115
reiteration, 102
relationships, 121; in experimental factory, 105–6
relativism, 7, 22–23
religion, 24–25, 31
replacement objects, 54
representation, 51–54
research, 23–25, 28; by artists, 122; of complete curator, 75–77
resistance, xii–xiii, 22
revolutions, 91–92; 1820 and, 22; 1974 and, 95–96; Scottish Insurrection as, 27–28; soft, xi–xiii

rights, 29–30
Royal College of Art (London), 73

sanctions, 58
scenario, 62–63
scientific research: as authority, 23–25; Beagle for, 23–24; belief and, 24–25; control from, 23–24; production and, 28
Scottish Insurrection, 27–28
secondary individuals, 29–30, 34
self, 61–62
self-awareness, 60
self-improvement, 115
self-management, 63, 97–98, 114
self-referral, 11
Sengupta, Shuddhabrata, 10
setting, 84–85
simultaneous realities, 15–16
singularization, 38–39
skepticism, 100
Skinner, B. F., 41
slavery, 23
Smith, Joseph, 24–25
social class: control and, 27–28; group nostalgia and, 112–13
society: artists and, 126–28; in 1948, 42–43; subjectivity and, 48
soft revolutions, xi–xiii
South Vietnam, 60
Soviet Union, 38
specialization, 39–40
specificities, 2–3
speculation, 13–14, 36
speed, 103–4
split, 17–20

Index

stress, 18, 21
structures, xiii–xiv; group nostalgia and,
115; parallel, 31–32. *See also* discursive
studio, 48, 50
subjectivity, 15, 17, 19; current art and, 1;
ontology of, xii–xiii; society and, 48;
work methods and, 11–12
sublimation, 6
supercollectors, 68–69
supersubjectivity, 15, 19
surveillance, 64
symbolization, 39–40

tautology, 51–52
technologies, xiv, 92–93, 95; architecture
and, 29–30; clone as, 61; computers
in, 63–64; containers in, 40; discovery
of, 26–27; of exhibitions, 32–33; from
military, 40–41; in 1948, 39–41; 1974
and, 96–97, 101; patents for, 26–27;
records in, 40
tensions, 18, 21; antiquities and, 25–26,
30–31; in discursive, 83; in 1974, 99; in
parallel histories, 28–30; of parallel
structures, 31–32
textual authenticity, 31
time, 103–4; aging and, 98; group
nostalgia and, 114; in 1963, 62–63, 65;
in 1974, 93–95
tradition, 100
transitions, xi–xii

transplantation, 61
twenty-four-hour news cycle, 94–95

unions, 43–44
United Nations, 58
United States, 37, 58, 93; control by,
22–23, 26–27; Europe and, 88–89
unity, 22–23
U.S. *See* United States
utopias, 44, 46; in 1948, 41–42

vehicles, 39–40, 106–7
Venus de Milo, 25
video, 67
vision, 24–25
Voice of America, 38
Volvo, 106–7

Walden Two (Skinner), 41
Wilson, Mick, 6
withdrawal, 123
With the Blood of Others (film), 113
work, 7, 49; as art, 109, 126–27; group
work, 105–6, 108
work methods: accommodation in, 8–9;
audience in, 9–10; biography and,
10–11; drive in, 10; flow in, 10–11;
nostalgia in, 9; self-referral in, 11;
subjectivity and, 11–12
work quality, 35
work week, 93–94